They don't want us to unite: All they want us to do is keep on fussing and fighting. They don't want to see us live together; All they want us to do is keep on killing one another

BOB MARLEY

DEDICATED TO

Jack Marley Riggs, jose pool, hank and swayne and All the Good People Who Lost Everything When the Levees Failed Them

Sittin' down eating an apple one day

Under the apple tree

Apple taste so good to me

I ate up your apple tree ...

Dave "Fat Man" Williams 1975

MICHELLE L. ELMORE

COME SEE ABOUT ME

FOREWORD

There is danger and dislocation in the streets of New Orleans, and too often a sadness born of pain, loss and injustice. Yet there is also devastating beauty of a kind that reflects and creates indelible joy. This beauty draws upon both grace and investments of time, spirit and hard work, and it is imbued with a dignity that can be neither extinguished nor taken away.

For anyone with open eyes and ears and heart, these truths reveal themselves as rolled into one larger transcendent truth, inscrutable at first and then slowly knowable—given the right attitude and approach—through immersion. This larger truth may be singular to New Orleans and to those born and raised in the city, yet it is rooted in many things (not least Africa) and is available to anyone who comes correctly and with modest and honest intent.

Those who arrive in New Orleans from elsewhere—those drawn in, who wish to understand and to participate—are first confronted with how little they know and later by how much there is to understand and to gain. I'd been writing about jazz for 20 years when I began my own process of immersion. Yet I was profoundly ignorant about what it means to have a living music, one that flows from and embeds everyday life — a functional culture that, as the clarinetist Dr. Michael White, who got his start in Doc Paulin's brass band, once told me, "speaks of the way people in New Orleans walk, talk, eat, sleep, dance, drive, think, make jokes and dress."

Michelle Elmore was born in Fresno, California in 1970. By the time she resettled in New Orleans, she had lived many places—Maui to Mississippi and well beyond. She had made it a point to visit nearly all of the United States but, as she says, "New Orleans is the only place that made me feel comfortable in my own skin."

Abandoned by her father as a baby, Elmore also lost her mother to a drunk driver at age five. The fact that she has less than a dozen photographs of her mother may have in part led Elmore to her obsession with capturing images of others on film. Her maternal grandfather once told her that when she visited the zoo as young girl, she never looked at the animals. She'd just watch the people. Such has been the focus of Elmore's photographs.

While studying graphic design at Mississippi University for Women, Elmore began teaching herself the art of photography. Her first mentor, Birney Imes, instilled in her a love of color film—she's stuck with film, never digital—and advised her to work in a photo lab. Her next mentor, John Klein, opened his camera shop and darkroom to her and explained that she didn't need a zoom lens—"because if I didn't care enough about my subject to get close, then why would I be photographing it?"

Elmore's life and her photographs are inseparable. For both, the foreground is the people Elmore held close in New Orleans. The background—the context, the connective tissue—is the cultural traditions and rituals that, in New Orleans represent everything from artistic expression to social activism to the normal course of daily life. Once Elmore resettled in New Orleans, she spent most Sundays at the weekly second-line parades. Her pictures reveal her bonds with the brass band musicians who lead these processions, the Social Aid & Pleasure Club members who, with love and dedication, organize these events, and the fancy dancers who captivate the crowd. This collection is titled "Come See About Me," which has nothing to do with the Holland-Dozier-Holland hit made indelible by the Supremes and everything to do with a line from "I Ate Up the Apple Tree," the title song of a 1975 album by Dave "Fat Man" Williams, who was once the Preservation Hall Jazz Band's pianist. You can hear that song at many parades, as Elmore did. But she first learned it from trumpeter James Andrews, who has been called the Satchmo of the Ghetto, in reference to the Tremé neighborhood that Elmore called home for two years.

From the start of her photographic journey in New Orleans, Elmore searched for Mardi Gras Indians, those feathered and beaded icons of the city's African American identity, and perhaps the most mysterious and elemental of all the city's culture bearers. "Let's Go Get 'Em"—the cry of battle in which Indians compete to be the prettiest, and a chant within the ritual enacted whenever they "mask"—denotes the collection of Elmore's photographs that trace what began as pure fascination with Mardi Gras Indians and grew into lasting friendships that inspired her own artistic ideals.

"Ya Heard Me," the third collection in Elmore's New Orleans trilogy, contains the most recent of her New Orleans photographs. These focus on a rap and bounce scene that extends a rhythmic revolution which began more than a century ago in New Orleans and defines anew the beat for this country's cutting edge. Elmore focuses squarely on the grills of gold teeth these rappers and bounce artists flash— outlandish and defiant declarations of style within a hostile and threatened environment.

Elmore began traveling to New Orleans in 1989, fresh from personal loss. A decade later, she was living in the city with her young son Jack Marley, their lives centered around the people and places, the sounds and sights, the rituals and rhythms captured in these frames. She left New Orleans in 2005, after the flood that resulted from the levee failures that followed Hurricane Katrina. She had $69 in the bank, and had lost many of her personal possessions. But she thought to pack up and move her negatives two weeks earlier.

Her search through those 12 salvaged boxes yields these images. They document the friendships that, for Elmore, transformed alienation into a sense of community, of family. They suggest joy and pain in elegant balance. And they pay tribute to the city that turned Elmore in the artist she sought to be, and that lent her art meaning.

LARRY BLUMENFELD: How did your fascination with taking pictures in New Orleans begin?

MICHELLE ELMORE: I remember trying to teach myself photography while visiting New Orleans. I was 19, still studying at the Mississippi University for Women. I walked all over the city, taking pictures of houses and trees and anything I saw. On Mardi Gras Day, I photographed a lady in Lee Circle who must have been in her eighties or nineties. She had pink angel wings on. The connection I made with her was totally different than with any other subject. I talked to her. I felt a real connection that I can't explain. Before that, I was basically trying to learn aperture, and how I could manipulate the camera. My pictures were more mechanical, and less my own expression. From then on, I photographed people.

LB: Mardi Gras Day is of course one defining moment each year in New Orleans. How has it affected your work?

ME: I can never forget one Mardi Gras Day I experienced in 1997. It was right after both of my grandparents died and I felt heartbroken and alone. I had a flat tire because I had run over a whiskey bottle. A guy stopped to help me the street, a total stranger. He asked me why my eyes were different than most white people. He didn't mean physically. He meant something else, and I understood. It was as if he could see all the loss in my life. And right then I understood that people in New Orleans deal with tremendous loss and struggle all the time, and that there's joy and faith that feels very real. I had never been in a place where you could look at death as a celebration of the person's life. For the first time in my life, I didn't feel alone. And that was it. I moved to New Orleans.

LB: What was the governing idea to your New Orleans photography?

ME: At first, I had none. I had been mostly doing random street stuff, portraits of people on the street. On the spot stuff with a shallow depth of field, just taking pictures of anybody. In New Orleans more so than anywhere else I felt comfortable to do that.

LB: But your immersion in second-line parade culture changed all that, right?

ME: Yes. When I started going to second lines, I noticed that a lot of photographers came out but nobody ever saw their stuff. So I began bringing my pictures back. I worked in a photo lab, so I would print my pictures and bring them back the next Sunday to sell to the people I'd shot. This paid for me to shoot film. It was an expensive hobby.

I quickly became known as the picture lady. I wasn't just another hanger-on using their pictures for whatever. I made friends. They'd ask, "Me-Shell—that's what everyone called me—Where's my picture?" I had more street credibility by charging people for these pictures than not charging them. People knew it was just a self-sustaining thing and it became part of the scene. I have to say that another reason that I really enjoyed shooting the second lines is that people let me know they appreciated my work. My pictures went in frames and walls in homes that I was invited into, and instantly it meant something to them and to me.

It began to dictate the rhythm of my life each Sunday. I'd go to second line all day, then go home, sleep, wake up, eat and go to Bean Brothers at night to see the Hot 8 Brass Band. We became good friends, and I spent a lot of time with the band both before and after Hurricane Katrina. I know there are a lot of photographs of second lines, and many of them emphasize tradition—like, this is where jazz started, which is true. But I tried to recognize the evolution of this culture, the way that brass bands like the Hot 8 and the Lil' Rascals have updated the repertoire and the sound.

LB: There's one picture here of kids dancing in front of the Lafitte projects, which are now gone. Does this hold special meaning for you?

ME: It does. I think that picture is from around 2000. It's just another second line. I spent a lot of time in the Lafitte. That project is gone, and now there are these prefab houses. That environment has been destroyed. And, ironically, those buildings were a safe place during a hurricane. After Katrina, the projects were closed off so that people couldn't even get back to get their stuff.

LB: How did you get immersed in Mardi Gras Indian culture, and what has it meant to you?

ME: I'll never forget that first time I saw them. I was driving along and the sun was setting and there was a flash of orange feathers. My heart jumped. I stopped and got out. I didn't take many photos, just three. Then, I handed my camera to some people with the Indians to take my picture with them. It was just a silly moment, but I suppose that eventually I became part of the picture for real.

I was just enamored from the start. A lot of the pictures that I saw of the Indians focused on the suits and they'd end up blocking out the faces. With the incredible amount of work and art that went into these suits, I felt it was important to

include the faces of these artists. It felt like it was no longer my art that I was doing separately. It felt more like an extension of what they were doing, and a way to honor what they had created. Their art is expensive and hard to do, and it isn't done for monetary gain. I admire that, and I relate to that. And these people got to know me. The Indians began asking me to come out with them to take pictures. The Black Feathers had me document one St. Joseph's Night, when the Indians come out after sunset.

LB: You have some pictures here of Tootie Montana, who was probably the most revered figure in Indian culture. What was that experience like?

ME: Those are from the last time Tootie masked on Mardi Gras Day. He wasn't really walking around in his suit by then. He was riding around in the back of a pickup truck. It was kind of sad that day because he had said that this was his last time. He was just getting too old.

I was introduced to Tootie years before that, and we were friends by then. He used to talk to me about the early days, when Indian suits were made from tin from the American can company, and how they would rattle and scare people. He always talked about making one of those suits again one day. Tootie was a true artist of the first order and a leader. He made people fight to be the prettiest as opposed to the toughest. He

used to explain to me how he went from being a craftsman making these crown moldings for buildings and then transformed those ideas into three-dimensional suits of beadwork and feathers.

I was there the next year, at the city council meeting where he died. I was four feet away when it happened, when he collapsed. I had been there on St. Joseph's night, when the police were chasing the Indians, which is what led to that meeting. They were driving on the sidewalks, chasing the Indians back. They were there to shut it down. They were wearing black bulletproof vests. They were aggressive and making things seem dangerous. So at that city council meeting, when Tootie got up and spoke, he said, "This has got to stop." And that was it. He collapsed. Everyone started singing, "Indian Red." It was sad and it was tragic, but it was a good way to go.

LB: The last piece of your trilogy is "Ya Heard Me." What's with all those gold teeth?

ME: At a certain point, I got fascinated with doing close-ups of people's gold teeth, the ones you see all the time in the bounce and rap scene in New Orleans. There's one I love here, of a guy called Money Mike. He told me that he worked for Cash Money. Of course, a lot of guys make that claim. Anyway, I ran into him on the street, and he let me photograph him.

I knew there was something special about these

teeth. But I didn't figure it out until I was living in Brooklyn, New York for a few months. My good friend Buster from New Orleans came to visit me, and he had a full set of gold teeth. We were in a McDonald's and, after he smiled, the girl behind the counter asked him to smile again. "Where are you from?" she asked. He told her "I'm from New Orleans," and he said it as if she should have known. Then Buster explained to me: In New Orleans, they file off the original teeth and replace them with gold, instead of these fake things, just covers. And you can really see the difference. In the old days, I guess when you flashed a smile with solid gold on the street it meant that you had real money, could do real business. And it still means something. So that's what these pictures are about. Whatever this means for a New Orleans rapper now.

I took 200 close-ups of these grills. They were a document, and they were something else, too. I would blow these pictures up to 40 x 60 inches, and they would look very surreal and erotic. The museum of Natural History in London included these in an exhibition of the history of diamonds.

LB: How did you end up in that community?

ME: Kind of randomly. I started photographing a couple guys. Word gets around fast in New Orleans about what you're doing— faster than the Internet. Everybody knew I was the girl photographing everybody's teeth. So if there was

a party going on or a video being shot, they'd tell me to get up there. I was an invited guest to Juvenile's wedding. When his photographer didn't show up, he got me to take the pictures. There I was at the altar.

I spent my last two years running around with these guys, right up until the flood.

LB: What do you think you gained most from the second-line parades?

ME: I gained a family. These people became my family at a time when I really didn't have one. And I was welcomed as family. I felt like each Sunday I was in some gigantic family gathering. If I wasn't there, people would call to make sure I was okay. I did it religiously every week.

LB: What about the Mardi Gras Indians—what did they teach you?

ME: Perseverance. Just to keep doing what you're doing. I never had enough money to do my art. They inspired me to keep going. It was a struggle. It was about getting better each time. That's what they do. They work hard every day. It keeps you honest. You keep trying to do your thing, and it keeps you from going the other way. New Orleans can eat you up if you let it. Doing what they do gives them a purpose and a function. And that's how I looked at what I was doing. At all the art shows I had, the Indians would show up.

LB: What about the guys with those gold teeth? What did you take from that experience?

ME: They're like soldiers, and you can really feel what that means. Everybody would judge them, but they didn't know anything about them. People would have this idea you shouldn't have gold teeth. Those guys lived in the moment. They didn't worry about what other people were doing or thinking. They worried about what they were doing and thinking. I liked that honesty. And they were dealing with hard truths. Life expectancy if you grow up in the projects is 25. You have to fight to make it. It's not easy. I wanted to show who they really were, what their teeth really looked like. And I guess I was also proving a point—that if you're not doing anything wrong you don't have anything to worry about. Nothing's going to happen to you. People aren't going to do something bad to you.

LB: Coming to New Orleans from another place, spending your time with a camera fixed on people who were born and raised there, did you ever feel like an outsider?

ME: Never, from the very start. Maybe it was because I'd experienced so much loss in my life, and maybe it was because I wanted so badly to find joy. But I thought from the very first time that I clicked my shutter in New Orleans that I belonged there, and then eventually I knew that I did.

--

Larry Blumenfeld writes about jazz and culture for The Wall Street Journal and many other publications and websites. His path first crossed Elmore's while working as a Katrina Media Fellow for the Open Society Institute, following the flood resulting from the levee failures. His essay "Band on the Run in New Orleans" appeared in "Best Music Writing, 2008" (Da Capo Press)

Ten Years from now where will I be? Will I be shining like a star bright
as the eye can see? Or will I be kicking the breeze hanging on
St. Phillip street?

LIL RASCALS

Library of Congress Control Number: 2017936081
ISBN: 9780998748429

Printed in China
Designed by Jen Zhao

First Artvoices Art Books Publishing edition 2017

Artvoices Art Books Publishing
www.artvoicesartbooks.com

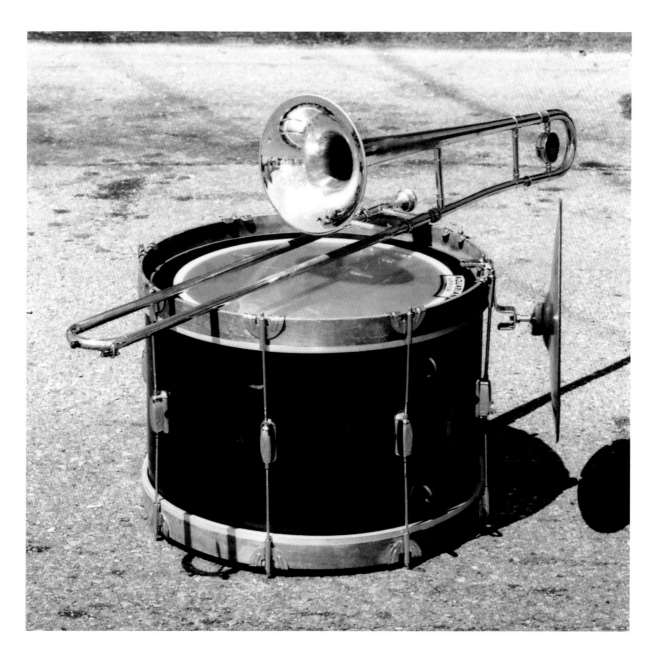

To Listen to Live Recordings Please Put Your Earphones On & Go To:

www.melodiusthunkproductions.com/comeseeme

CODE: COMESEEME

"The "second line" name is taken from the jazz funeral tradition: the first line is the family and friends of the dead while a second line of marchers gathers behind and alongside them, anticipating the upbeat dance music after burial. The name also refers to the weekly parades sponsored by social clubs, whose members parade through their neighborhoods on Sunday afternoons."

By Matt Sakakeeny
(Red Bull Music Academy Daily)

OCTOBER 15, 2013

In 06 I had the Quixotic experience of traveling 5 mph in a Chinese car up and down narrow rolling roads through the mountains of Cuba during the Golden hour with Michelle yelling, "Stop, Stop," every forty seconds despite having suspicious government spooks floating nebulously everywhere round our tail. I'd stop and she'd leap out of the car and I'd jump out the car and she'd bend, lean, lay, contort, with still, Zen breath and click, click and she'd glow then smile. I'd look close as she shot but everything looked like everything else to me. I got worried but said nothing. I was already well aware that Michelle has the grand gifts of grit, fearlessness and foresight combined with a working woman's work ethic and love of the people and places she's photographing based on her abundant talent, precise trade-craft and fundamental philosophy that life is precious and tomorrow is promised to no one. Throughout Cuba any place we went twice people would light up and smile and greet her warmly. In the years since Cuba I've witnessed this uncanny reaction to her spirit everywhere we've traveled. That evening in the mountains she showed me what she'd shot that day — my jaw dropped — her photographs popped off the screen — what had seemingly not been there to me really was there; vibrant faces, landscapes, the wheels of life in subtle action with the light framed just so by an experienced eye that sees the mysterious well beyond the veil. This is Michelle's hallmark; prescience, detail, the epiphany of the extraordinary laced through the ordinary so if you look closely at her work you can see the Divine. These traits are also the same qualities of a master artist which the following pages will reveal.

NELSON EUBANKS

MICHELLE L. ELMORE

COME SEE ABOUT ME

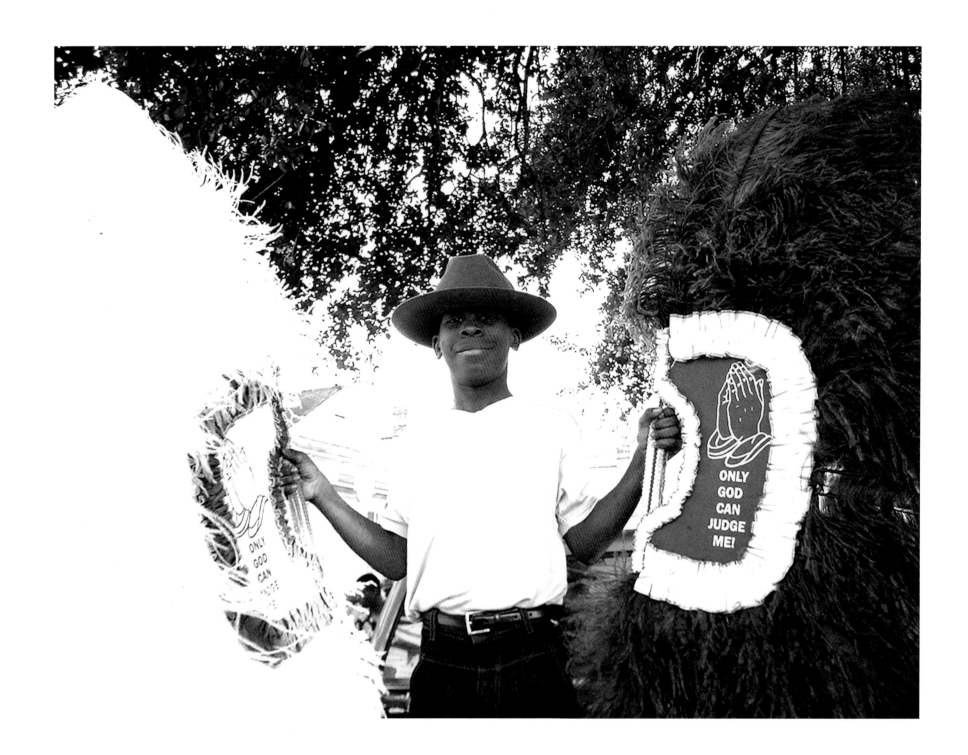

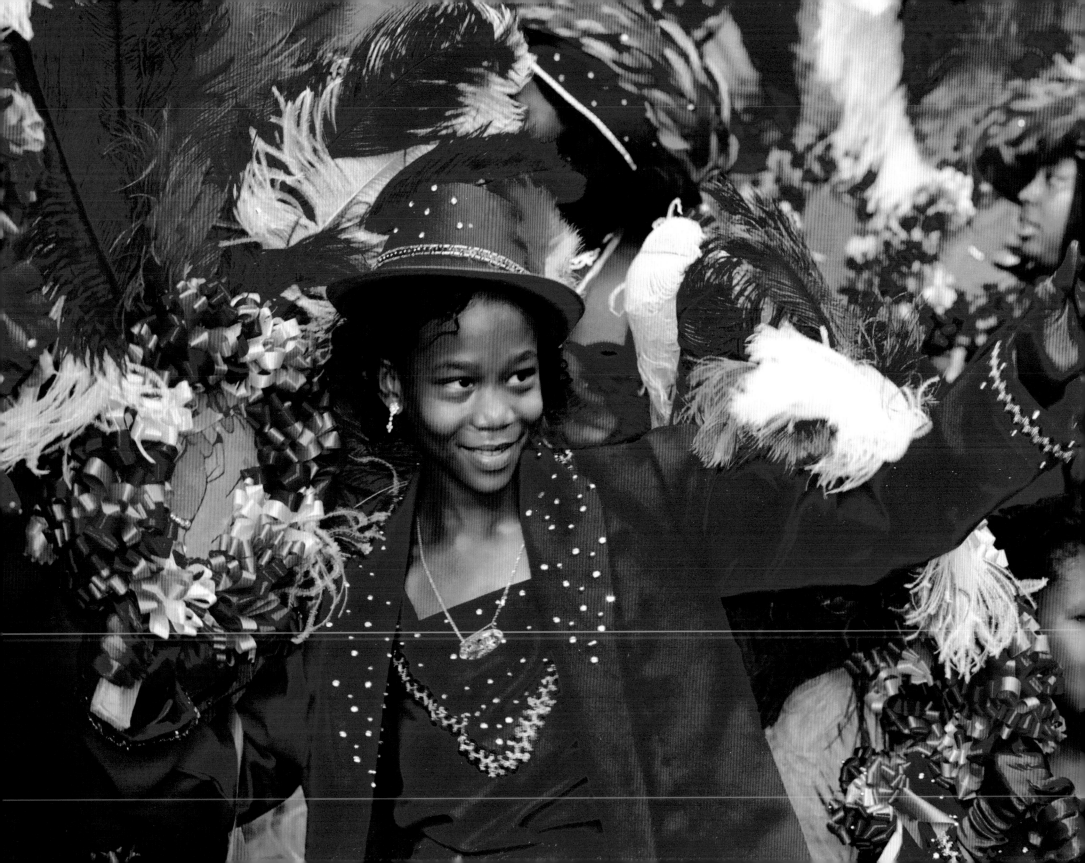

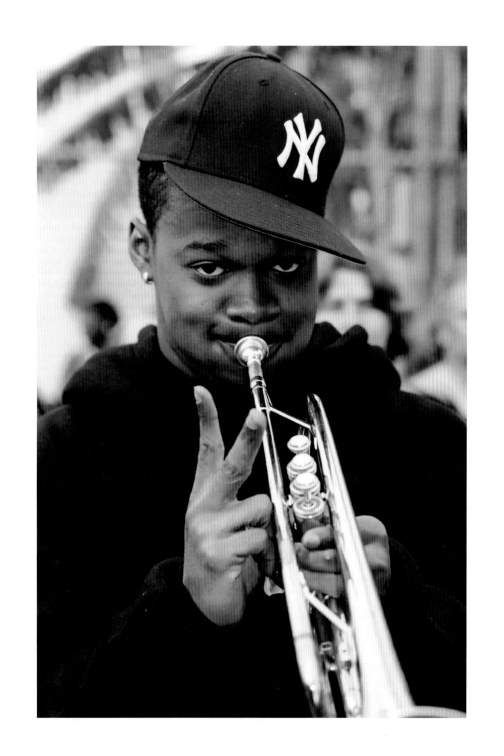

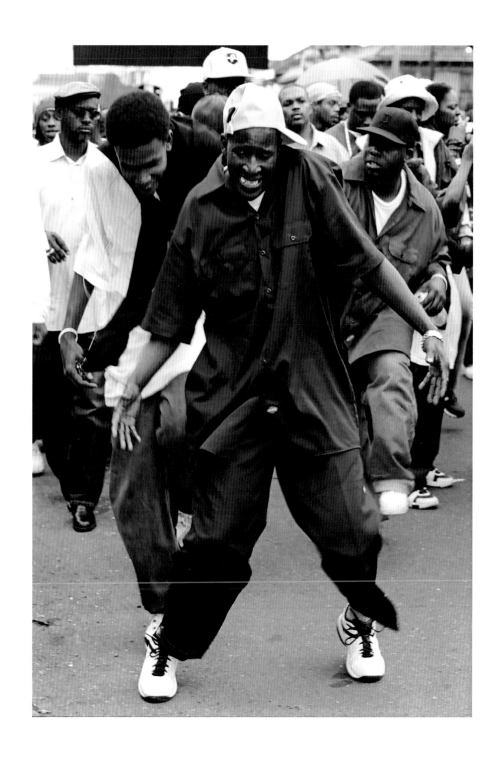

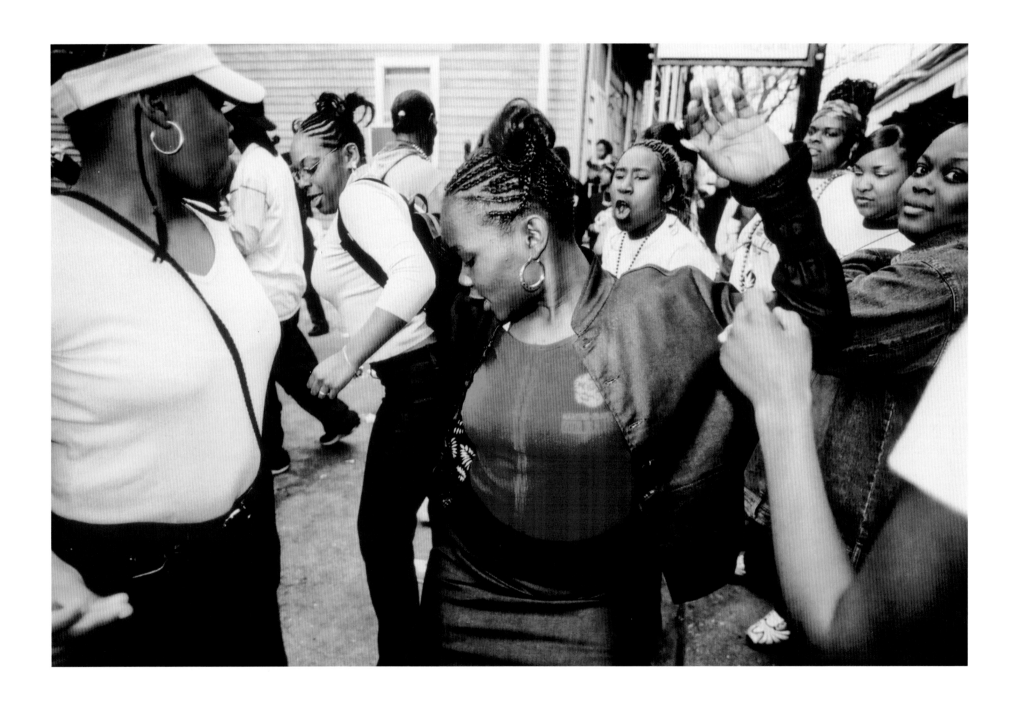

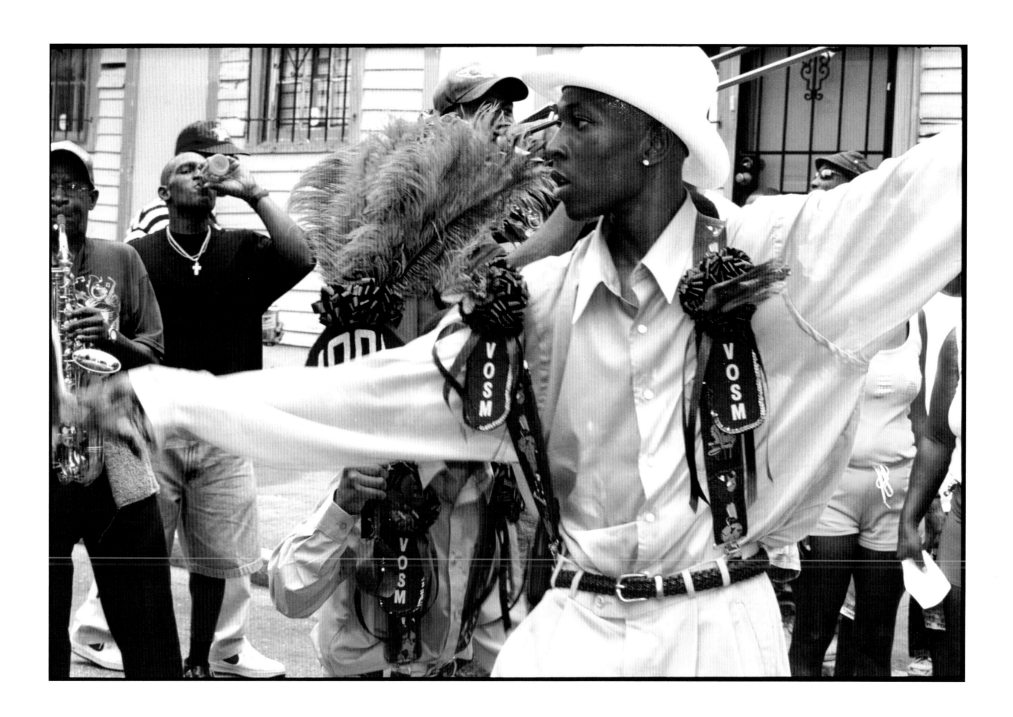

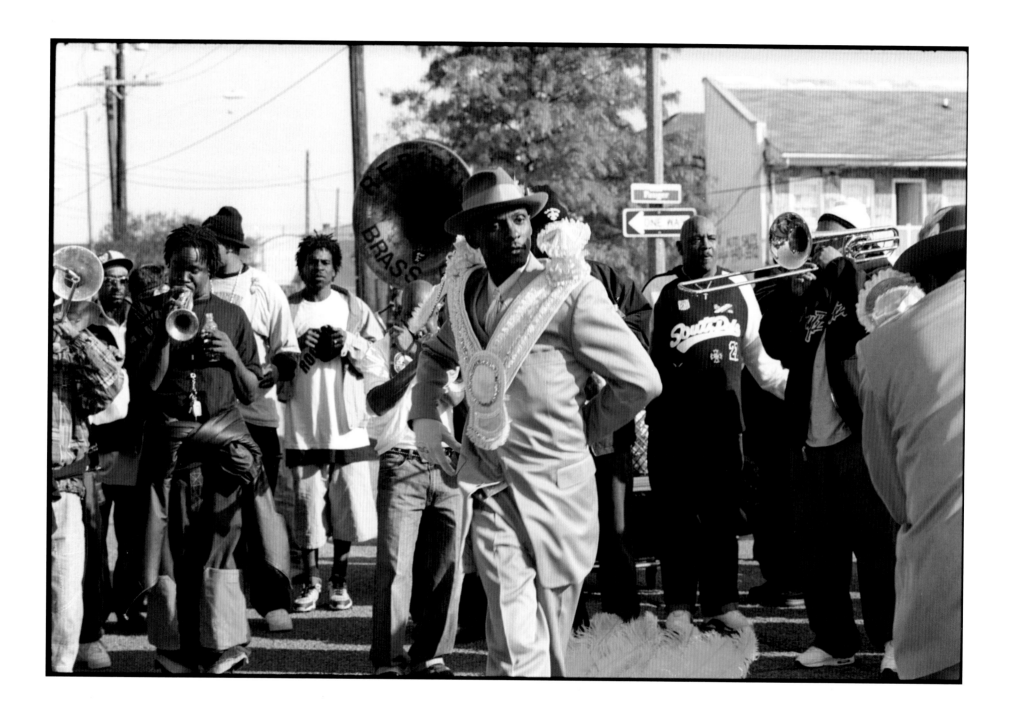

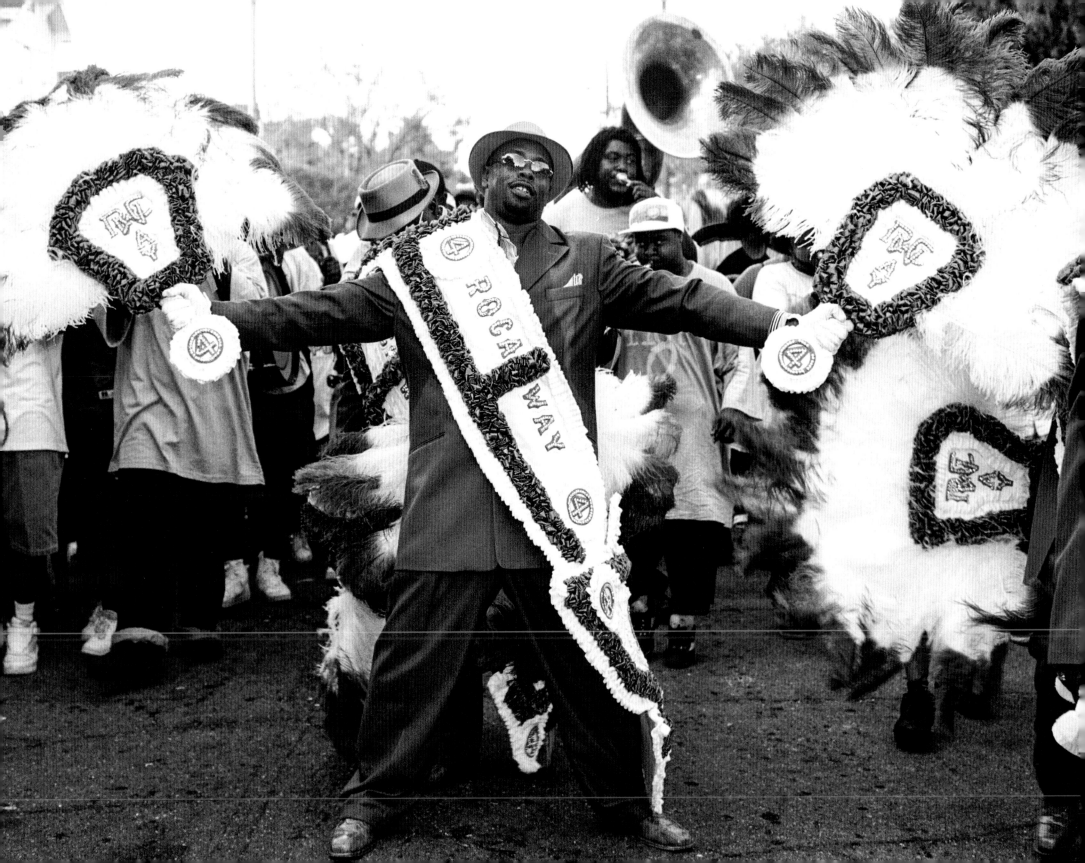

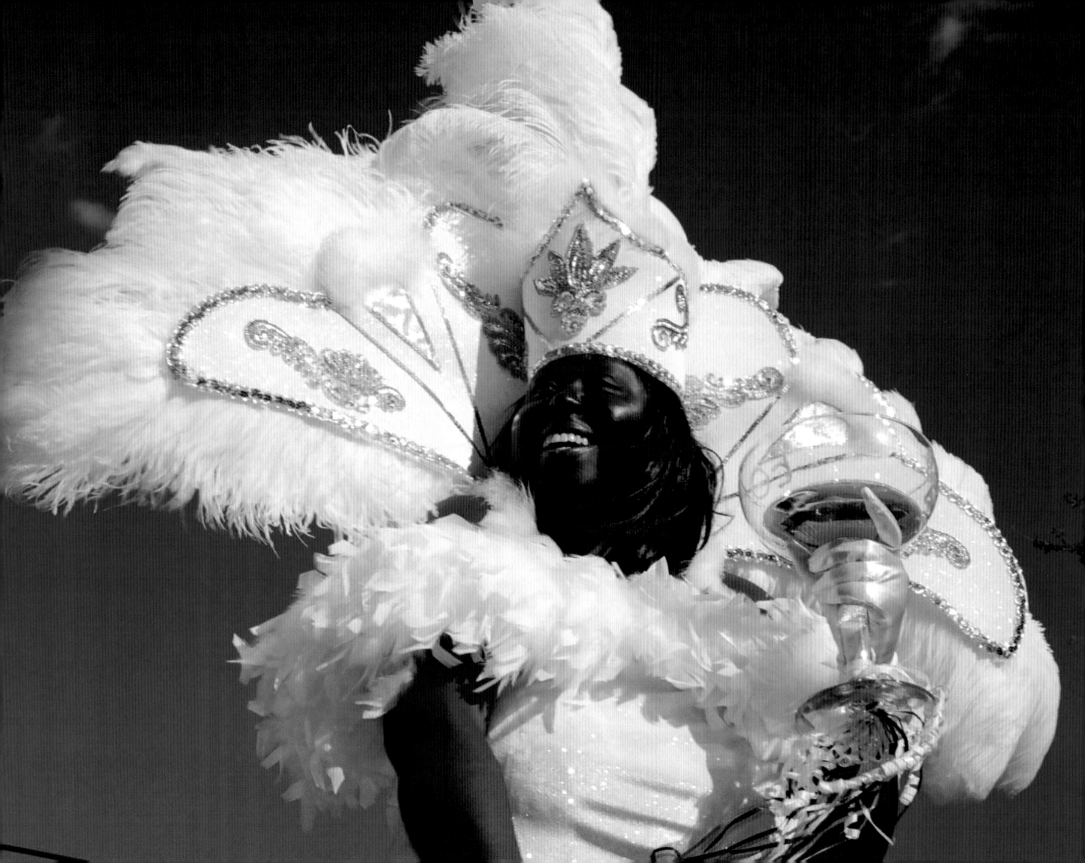

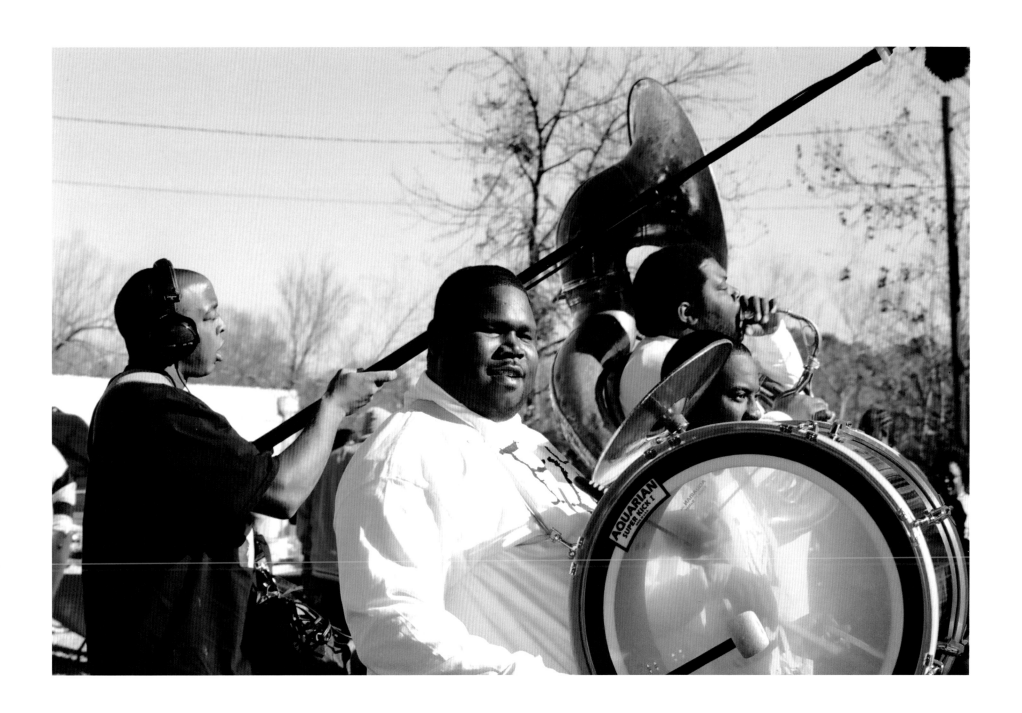

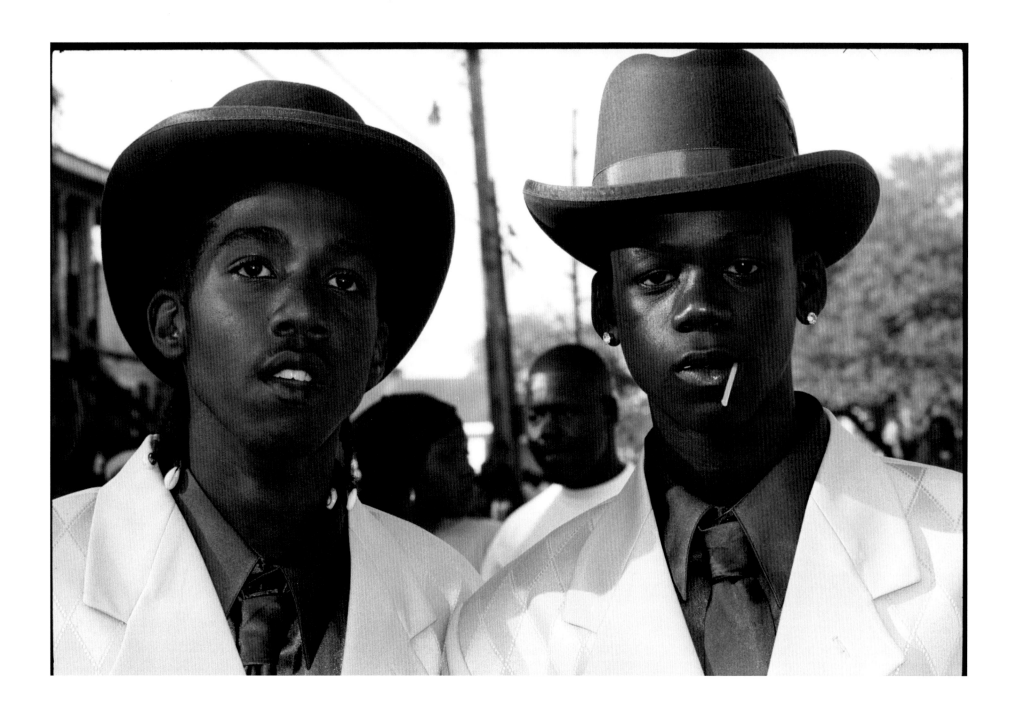

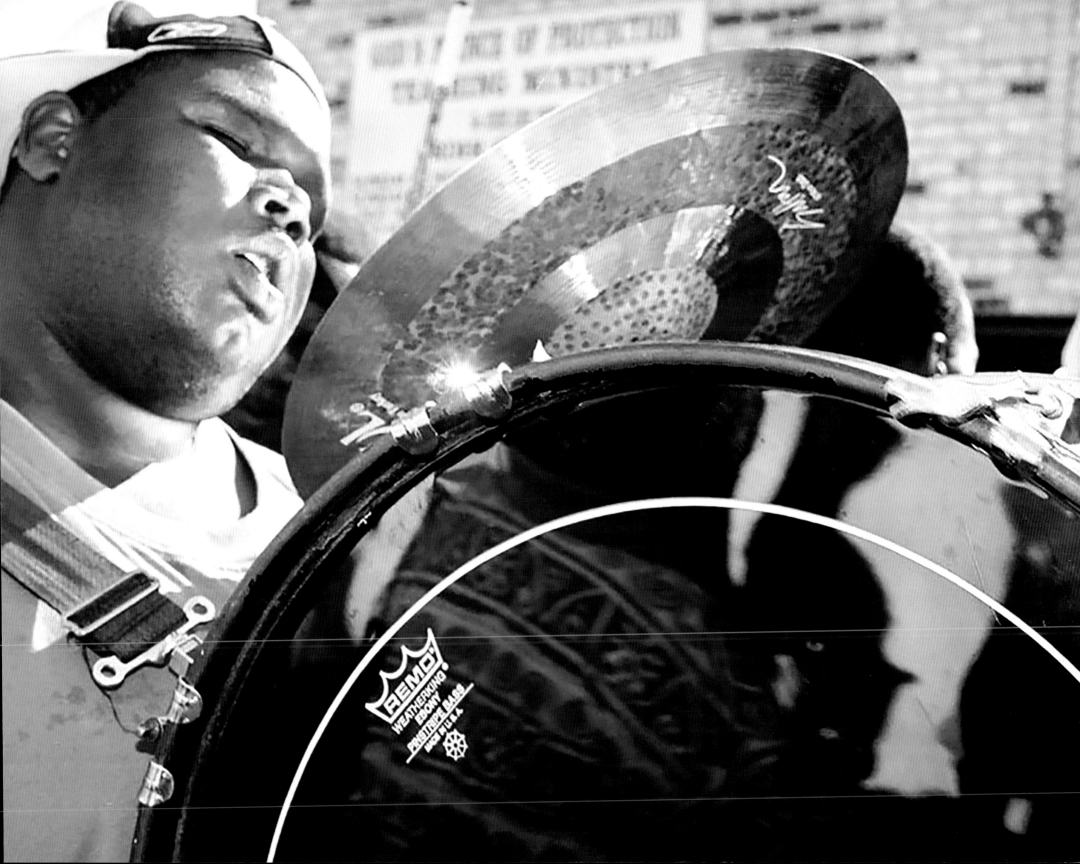

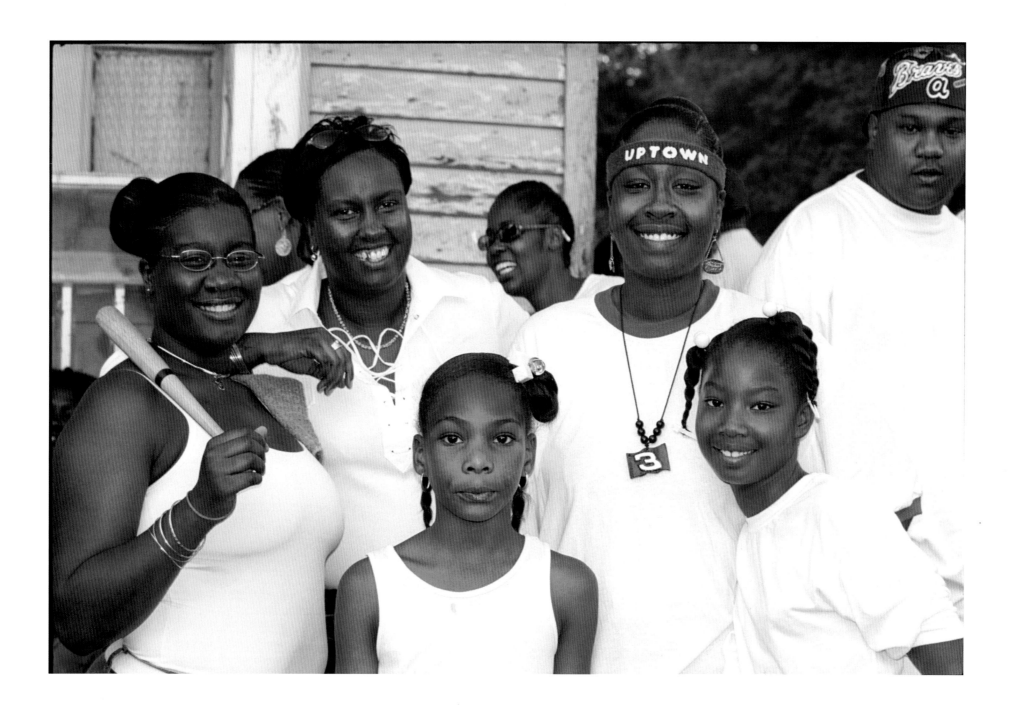

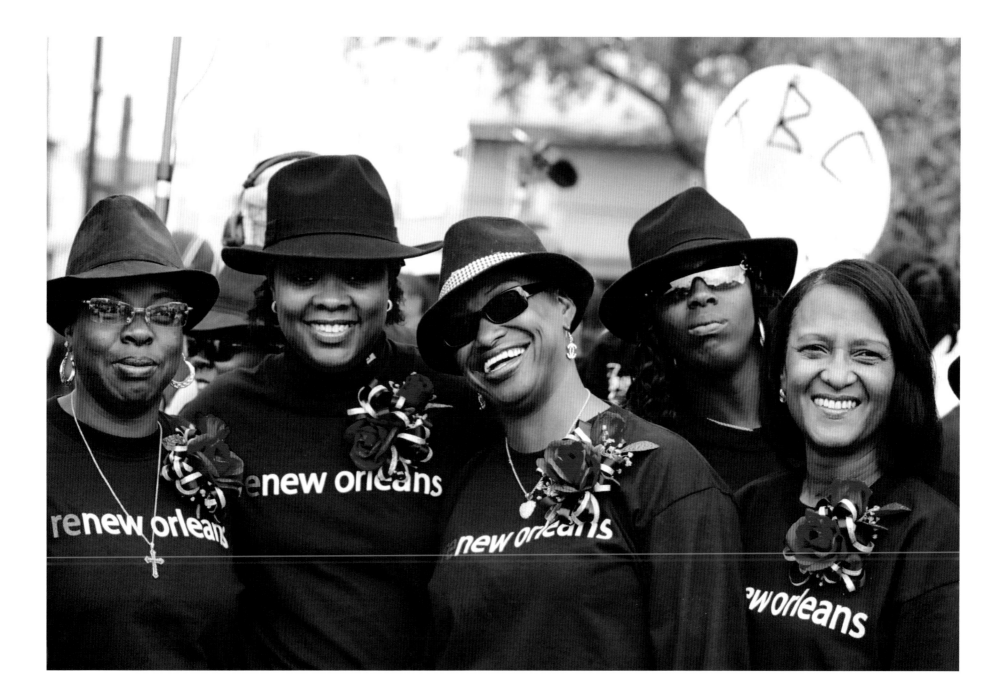

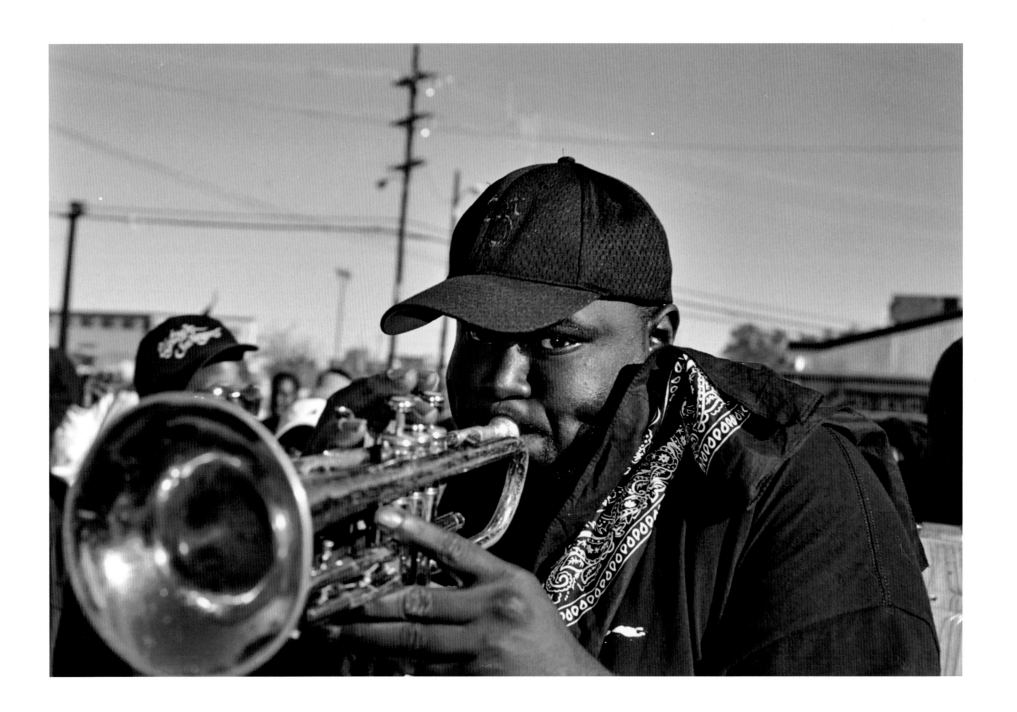

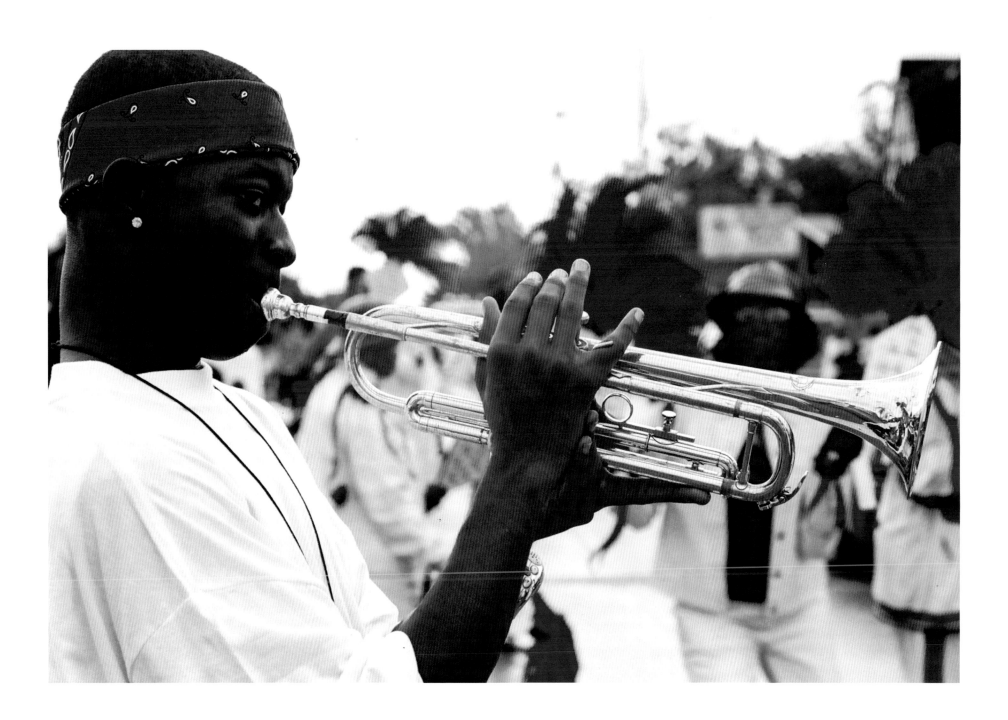

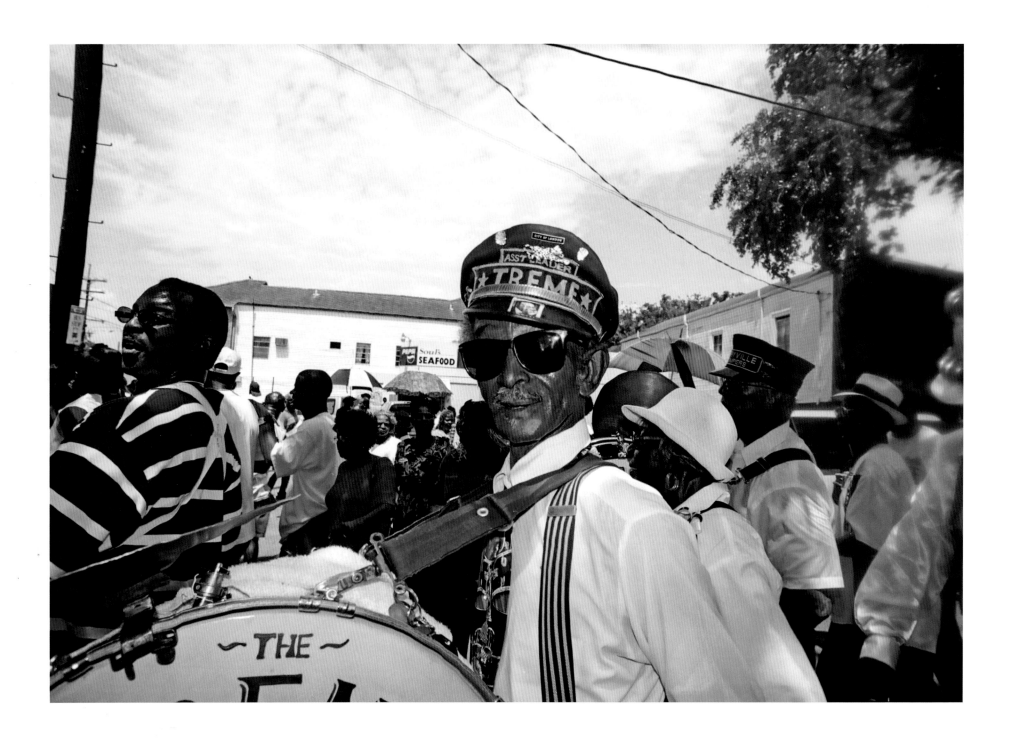

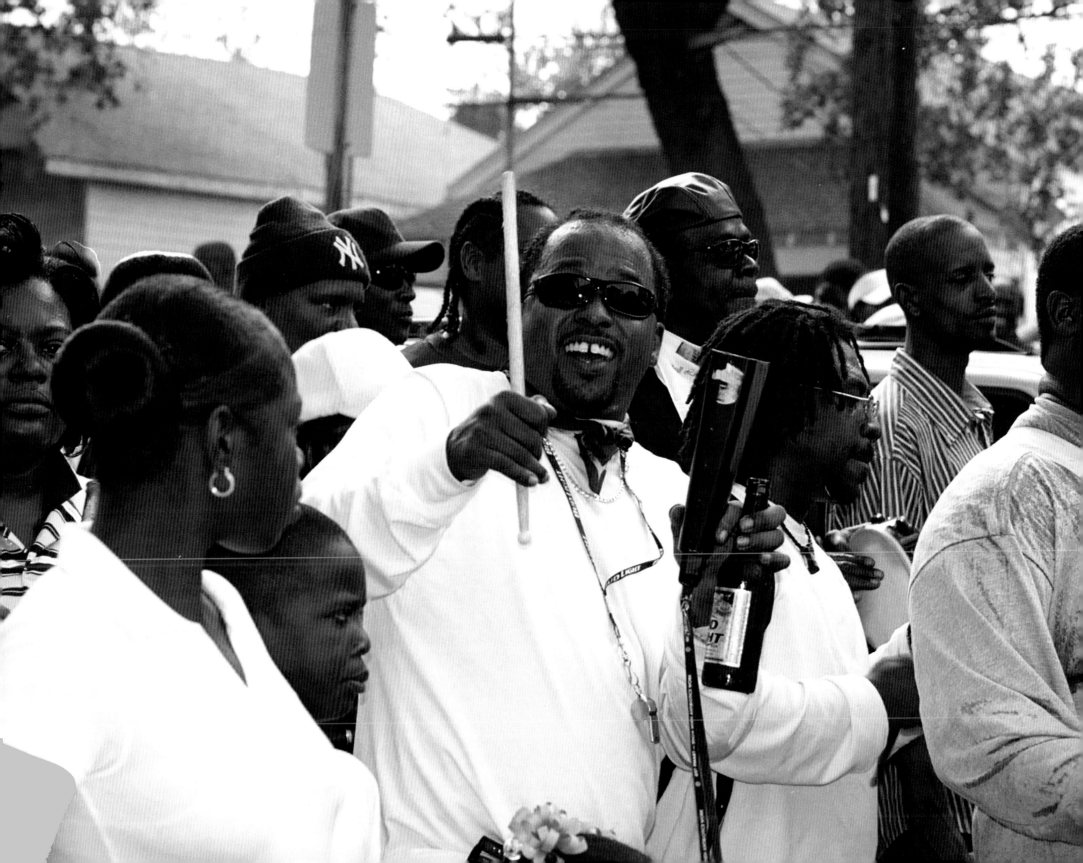

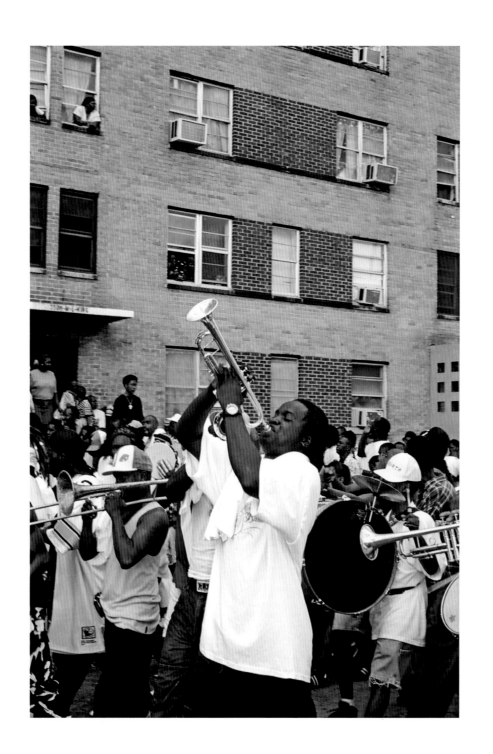

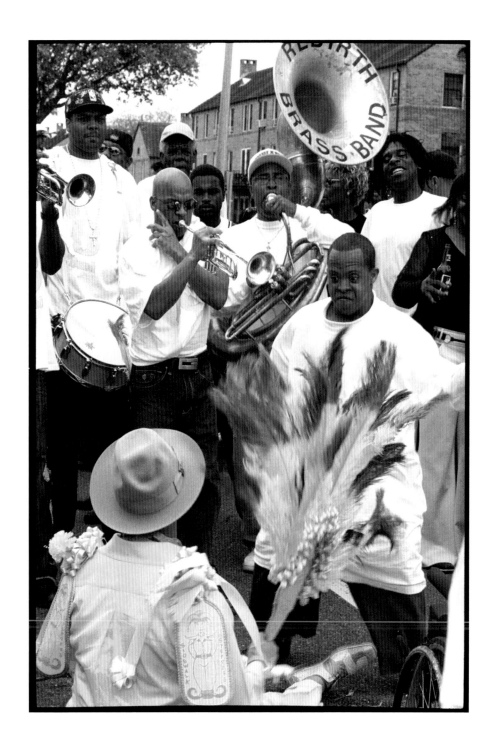

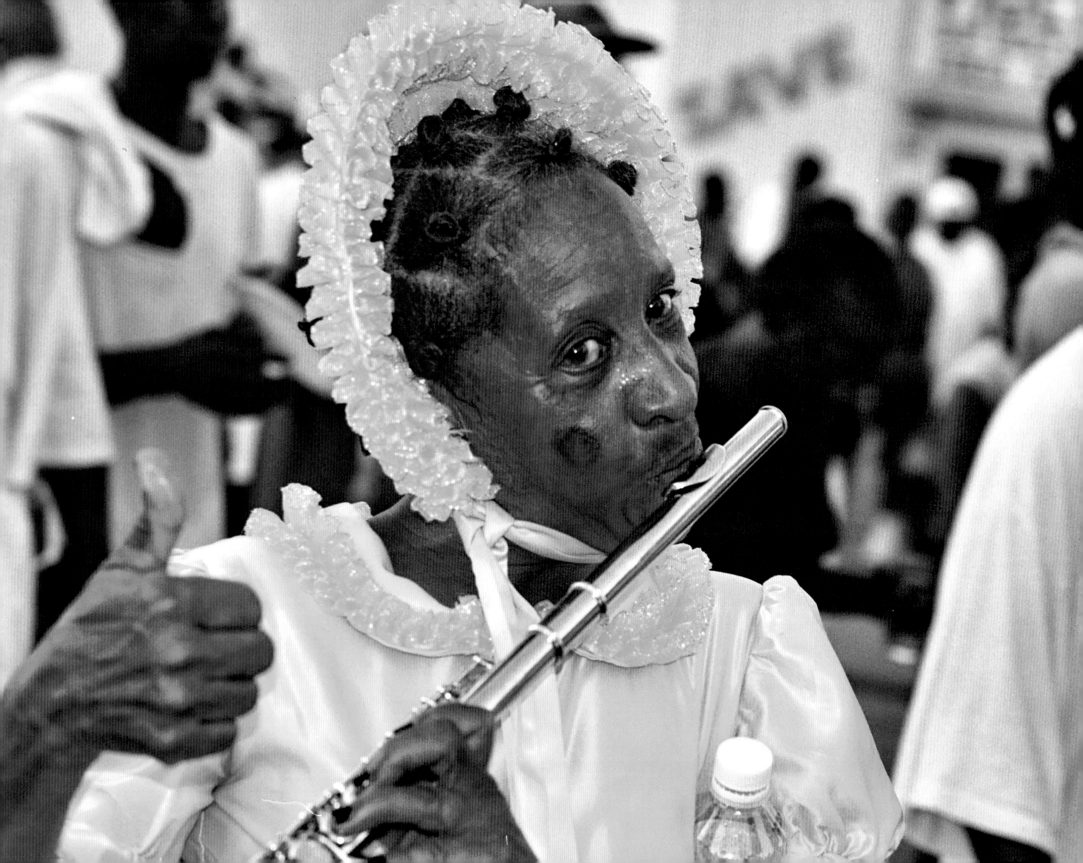

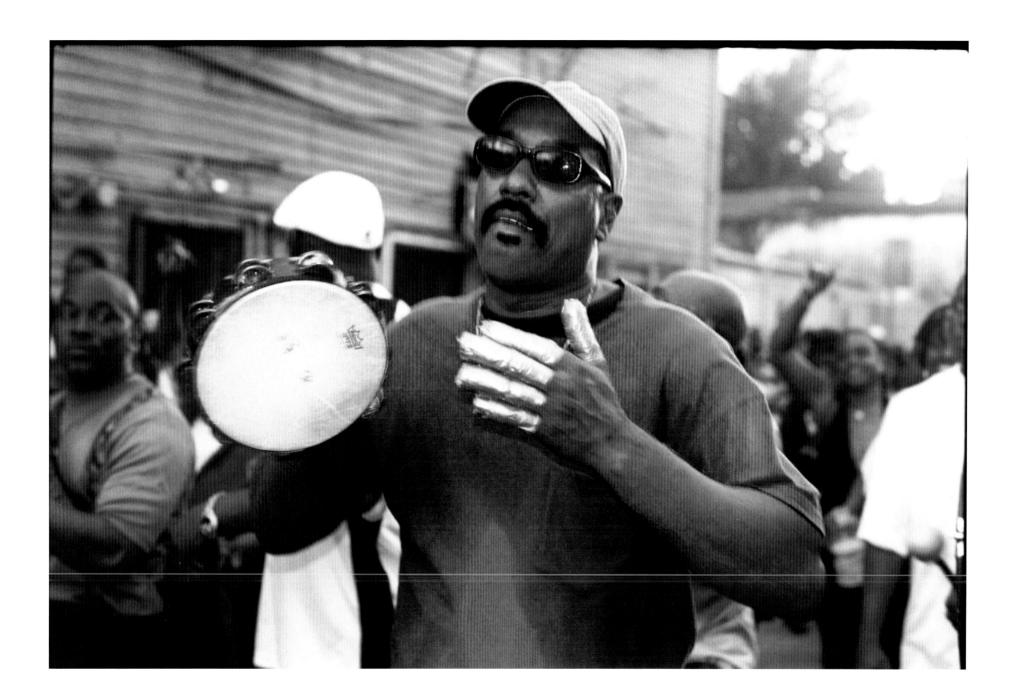

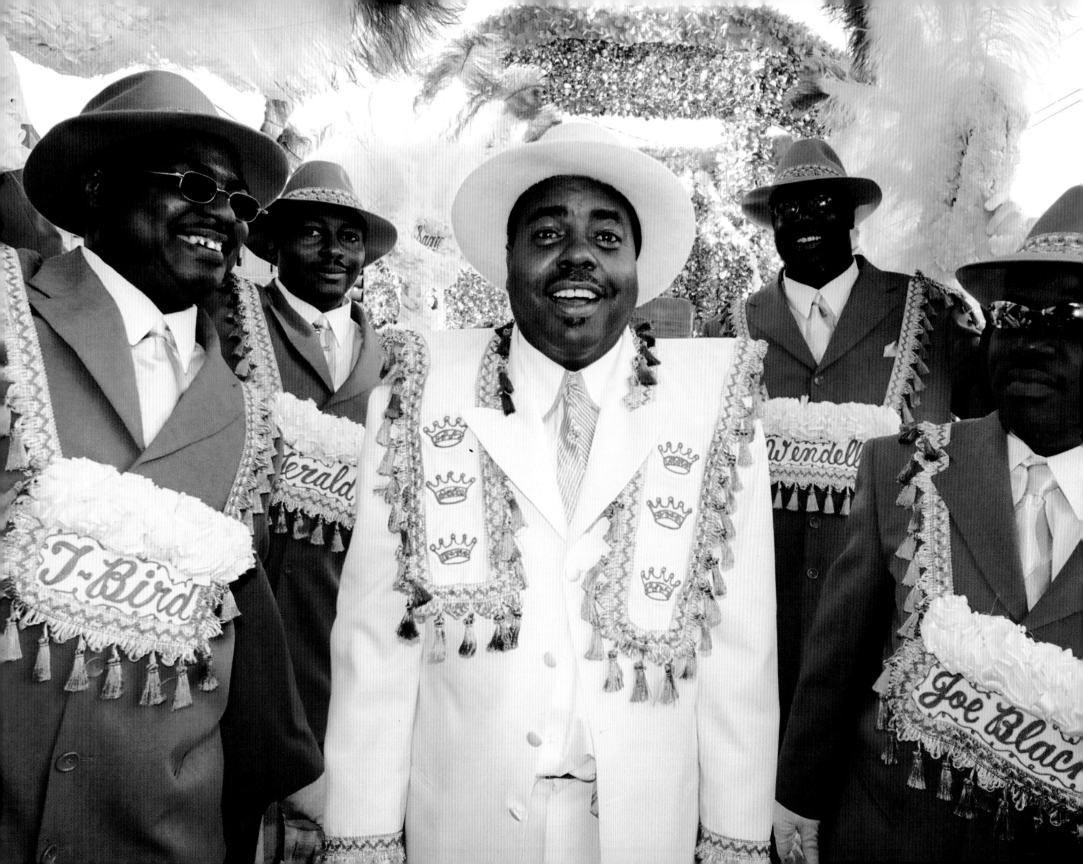

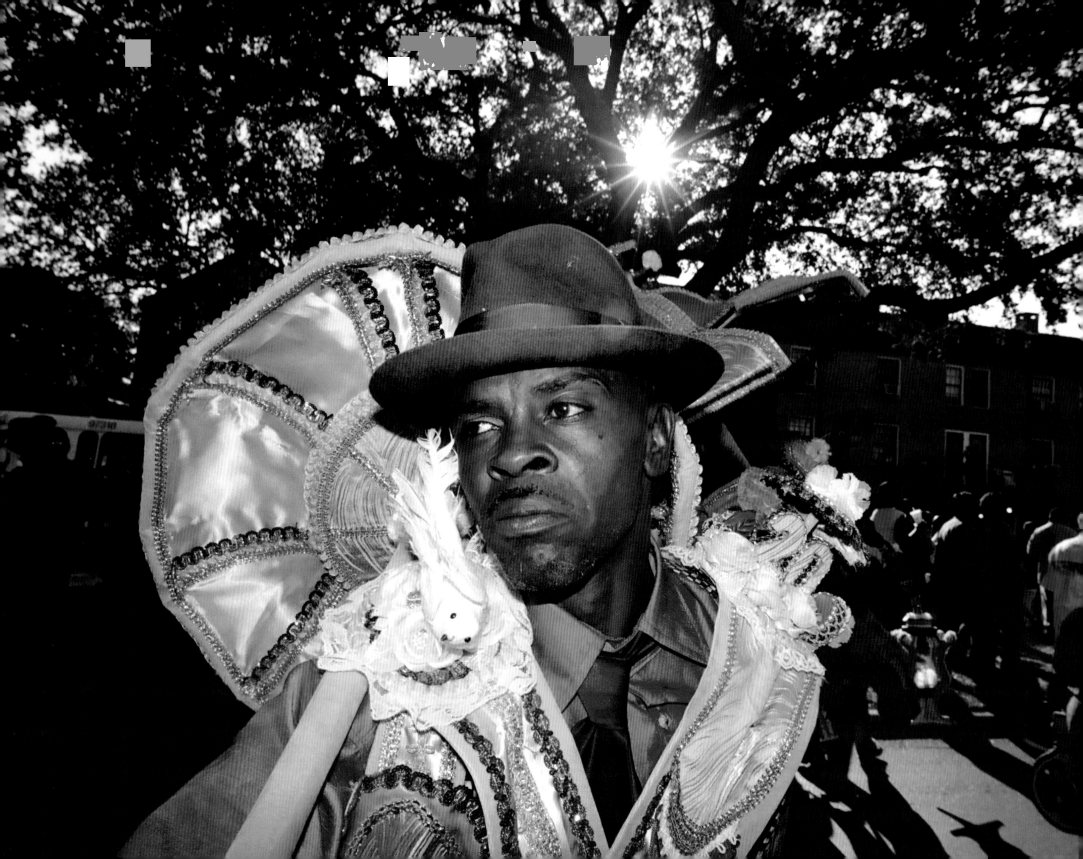

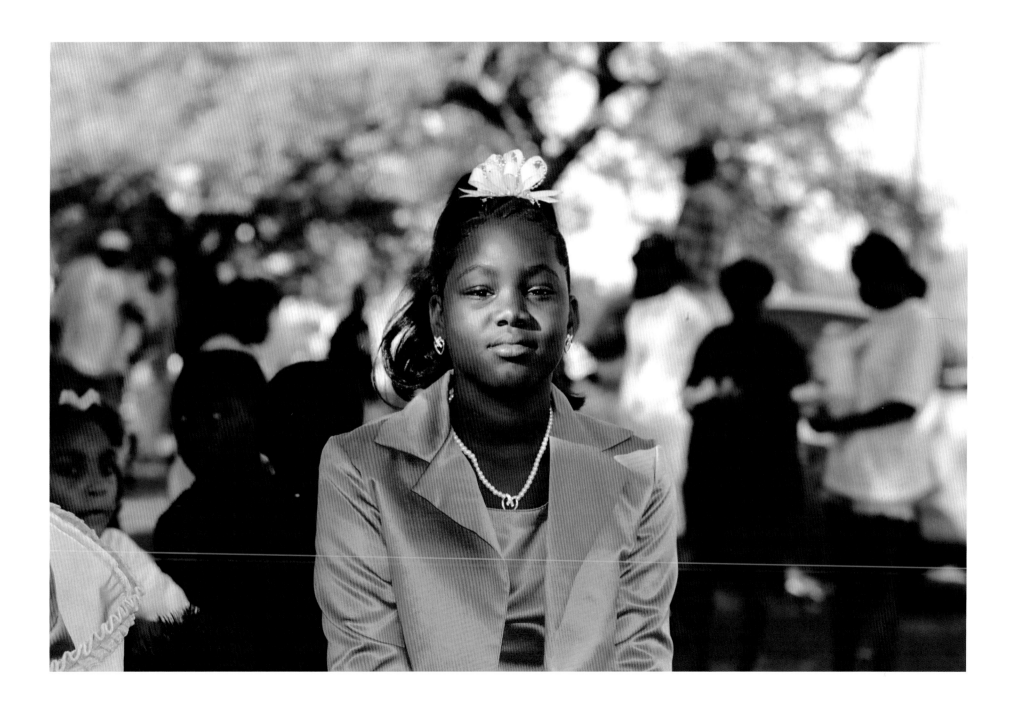

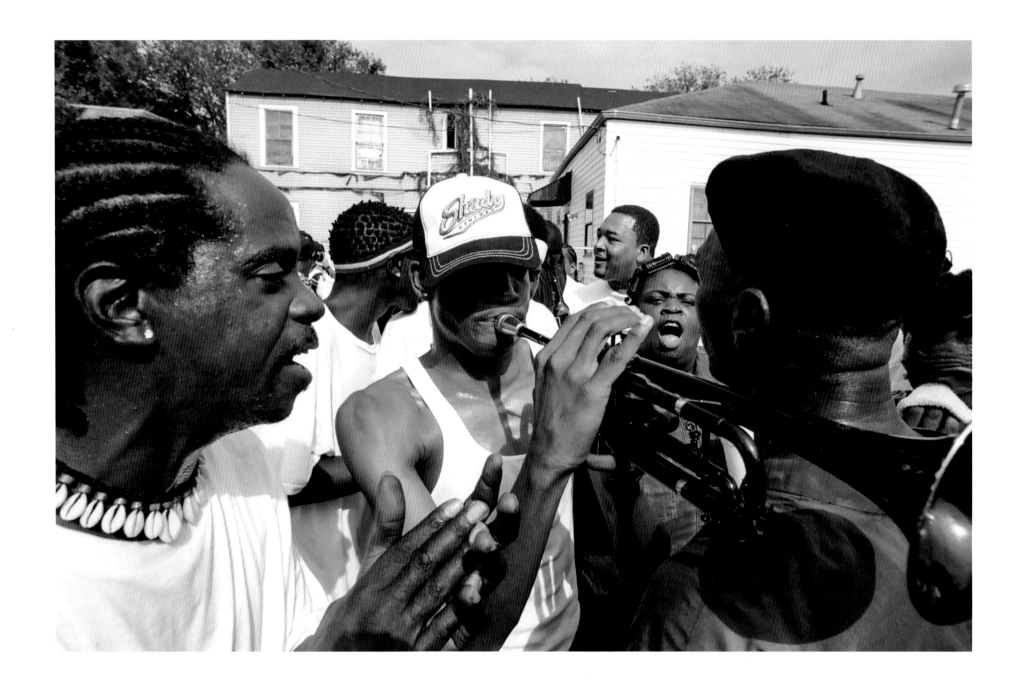

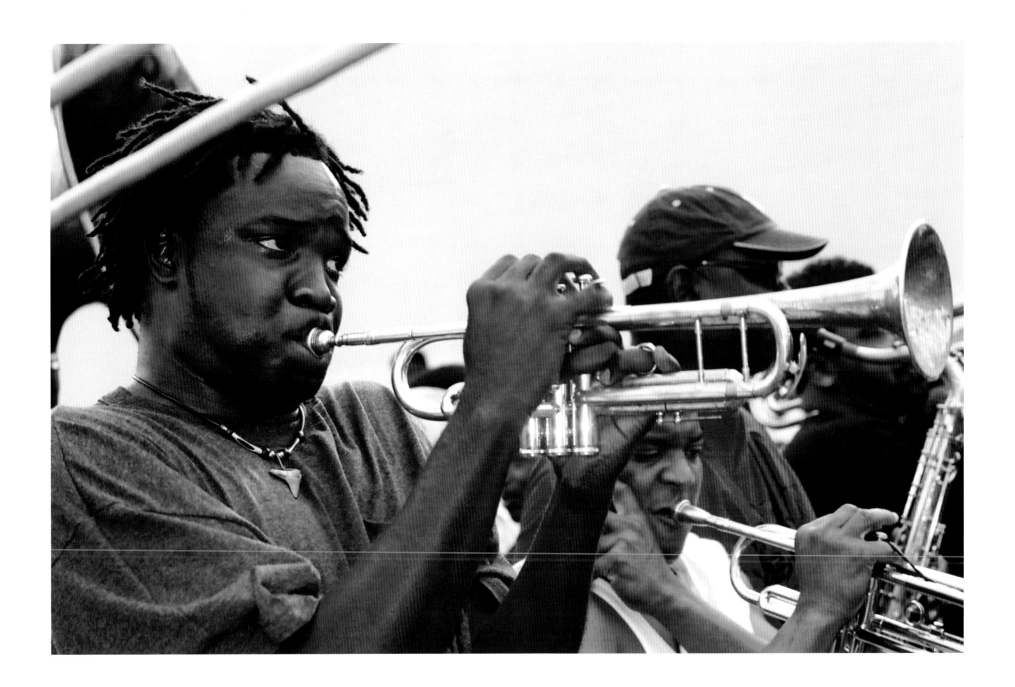

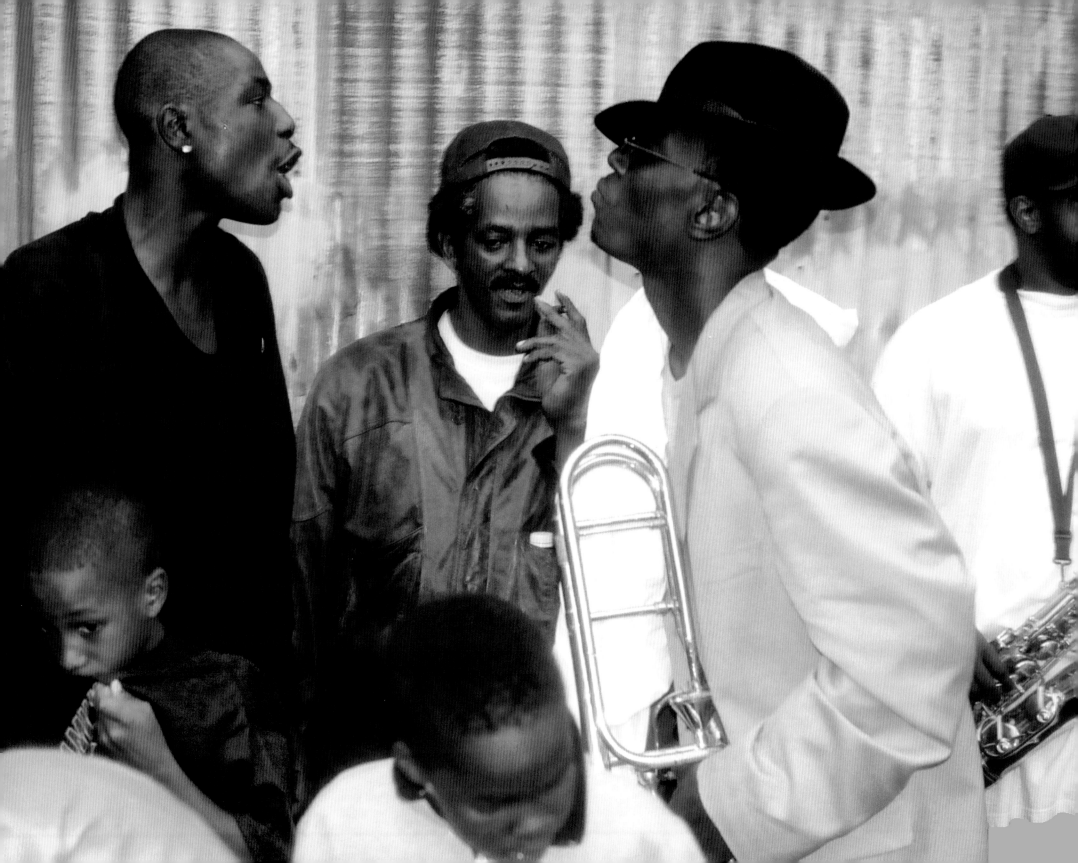

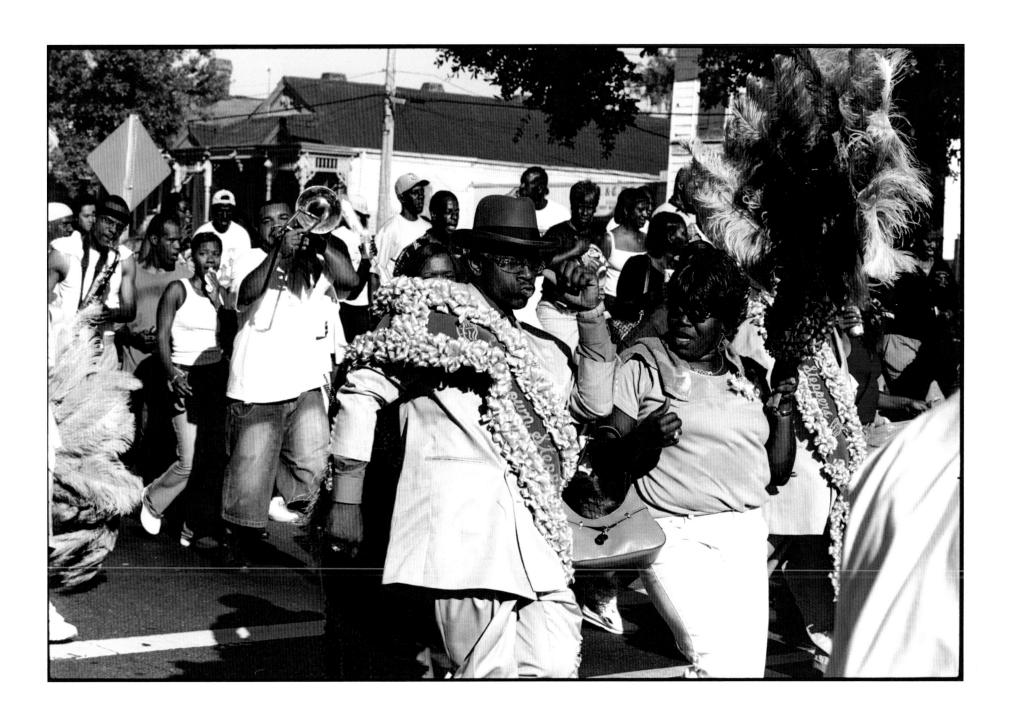

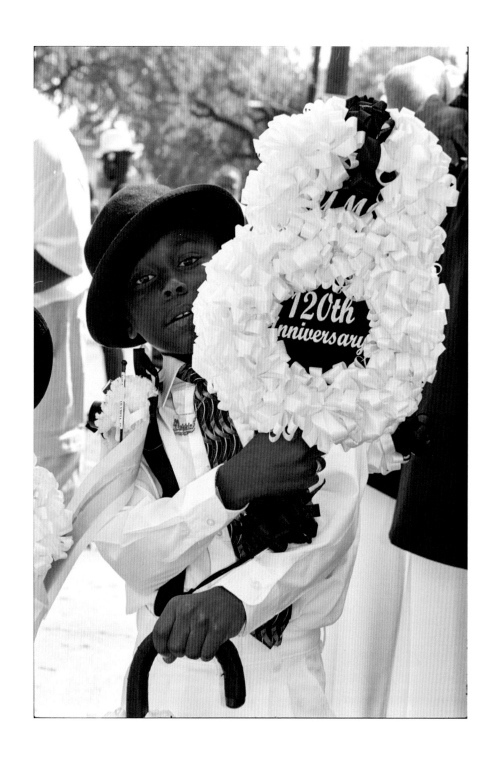

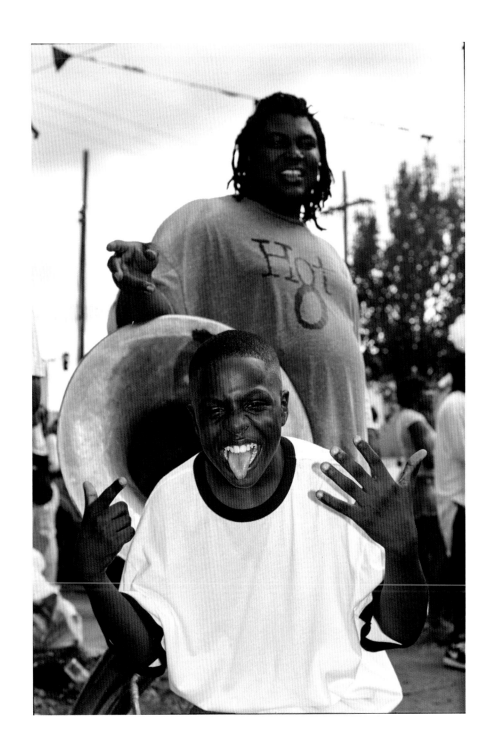

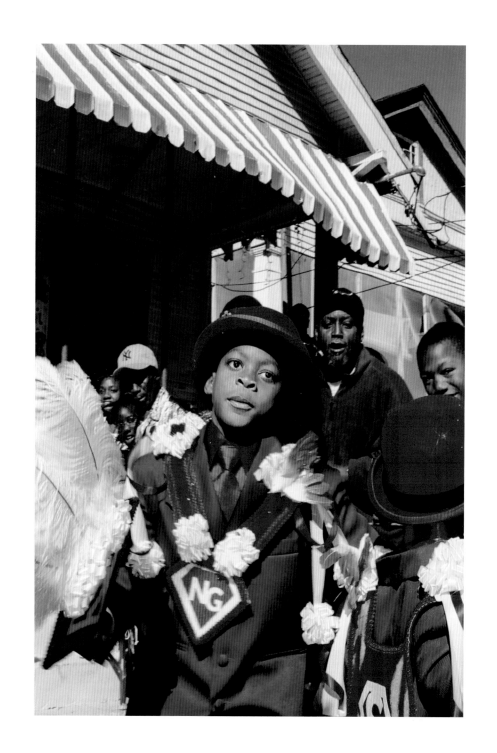

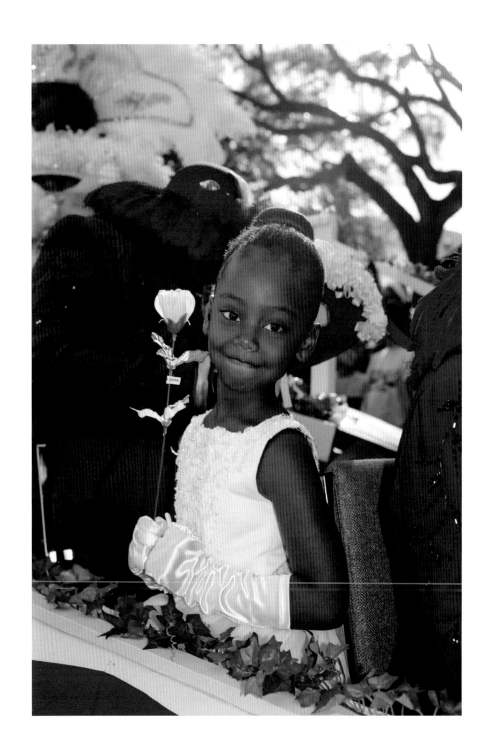

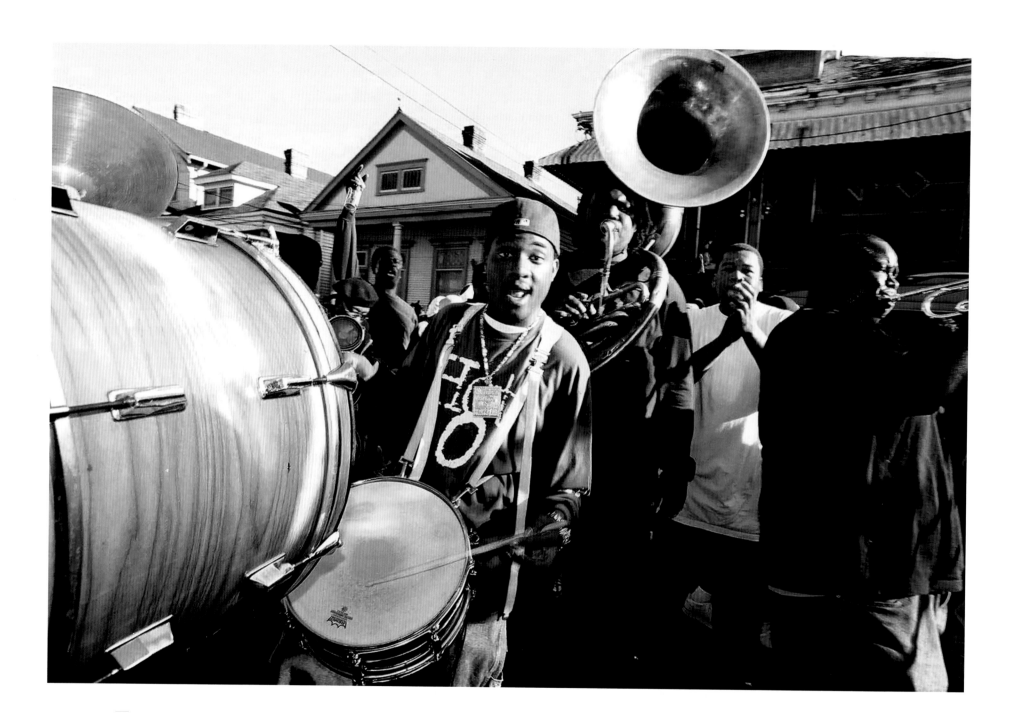

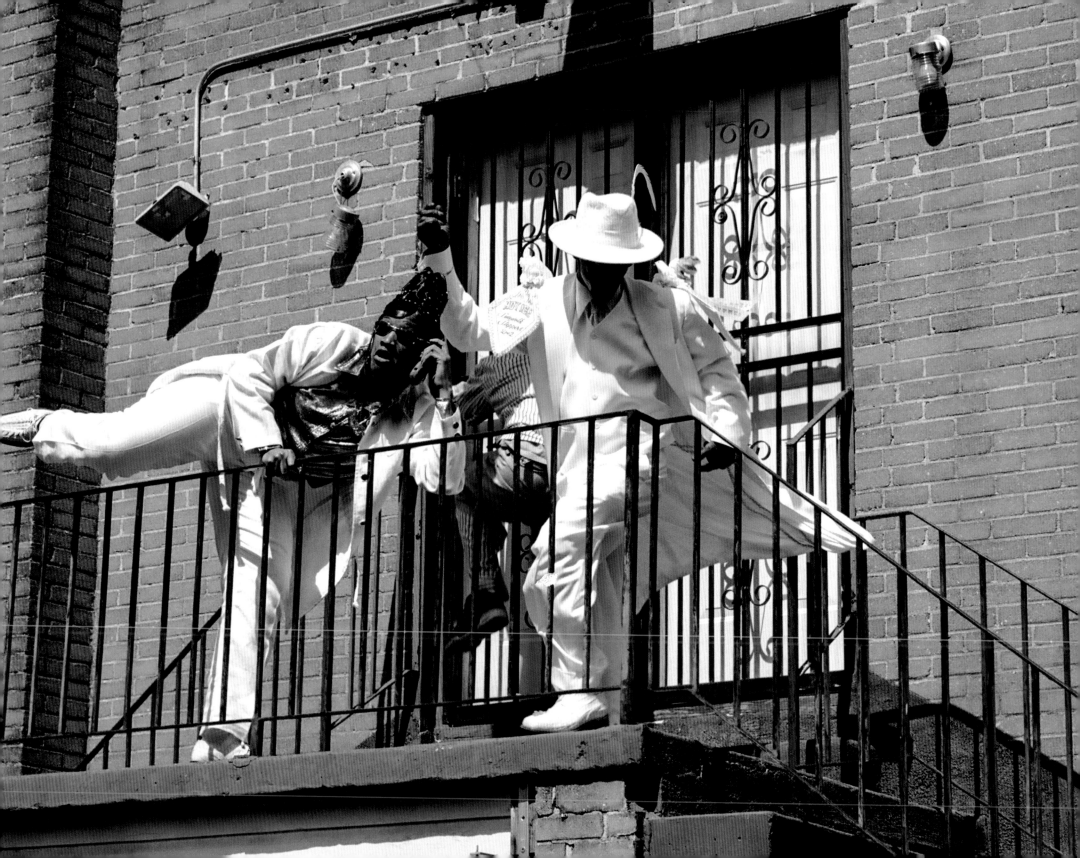

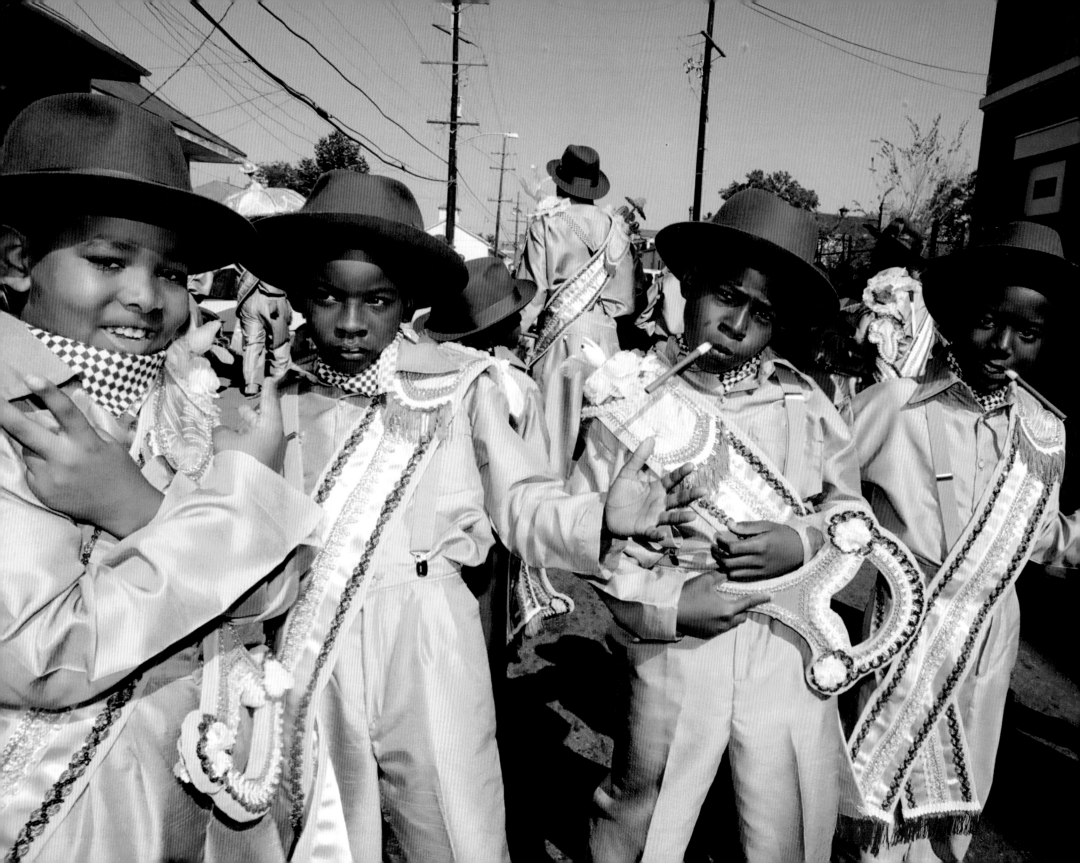

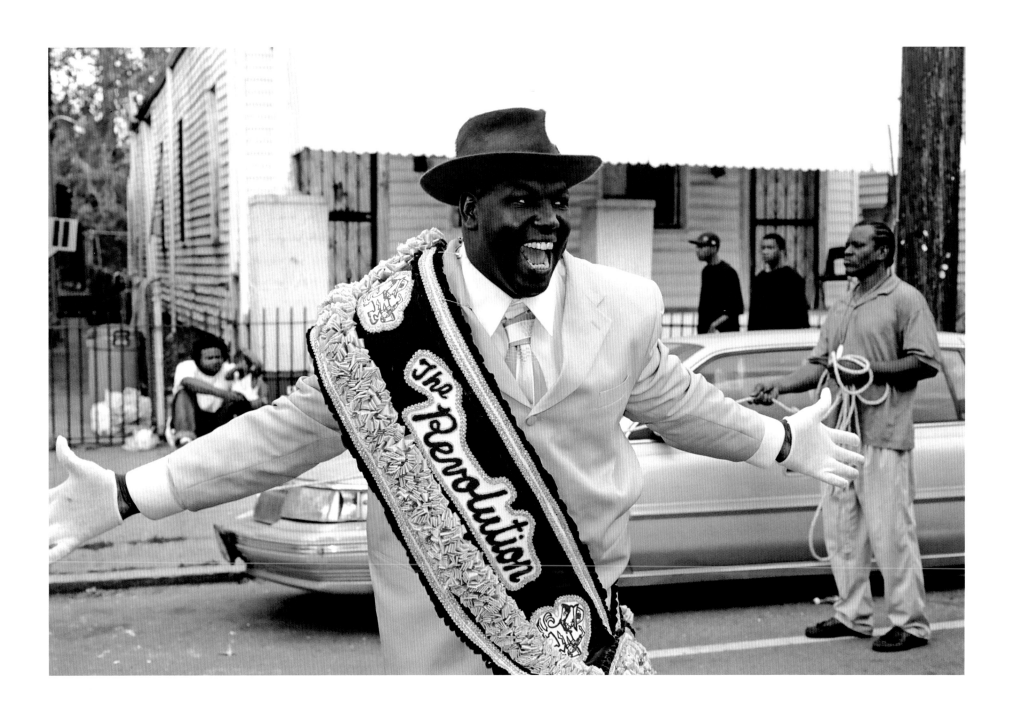

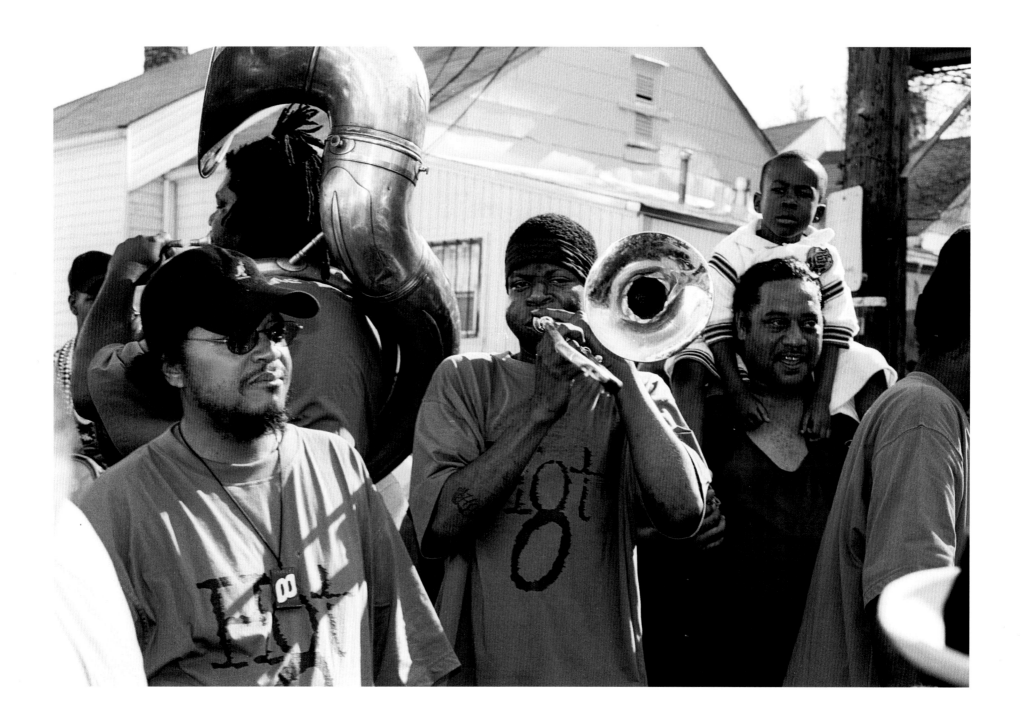

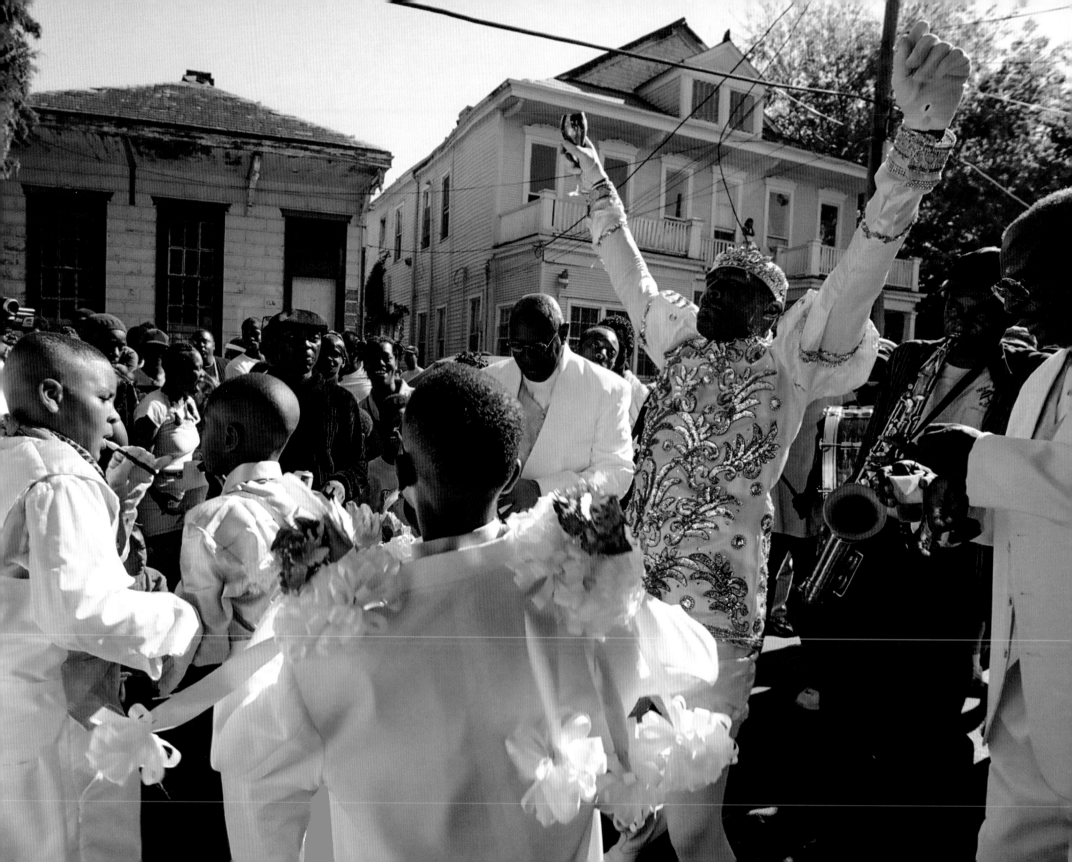

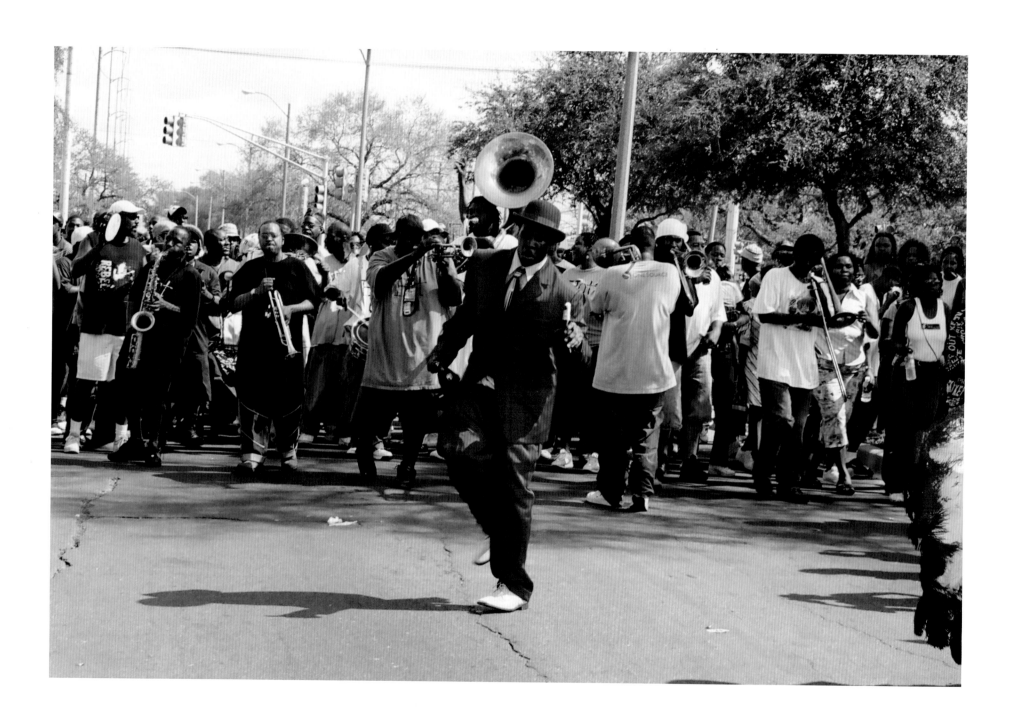

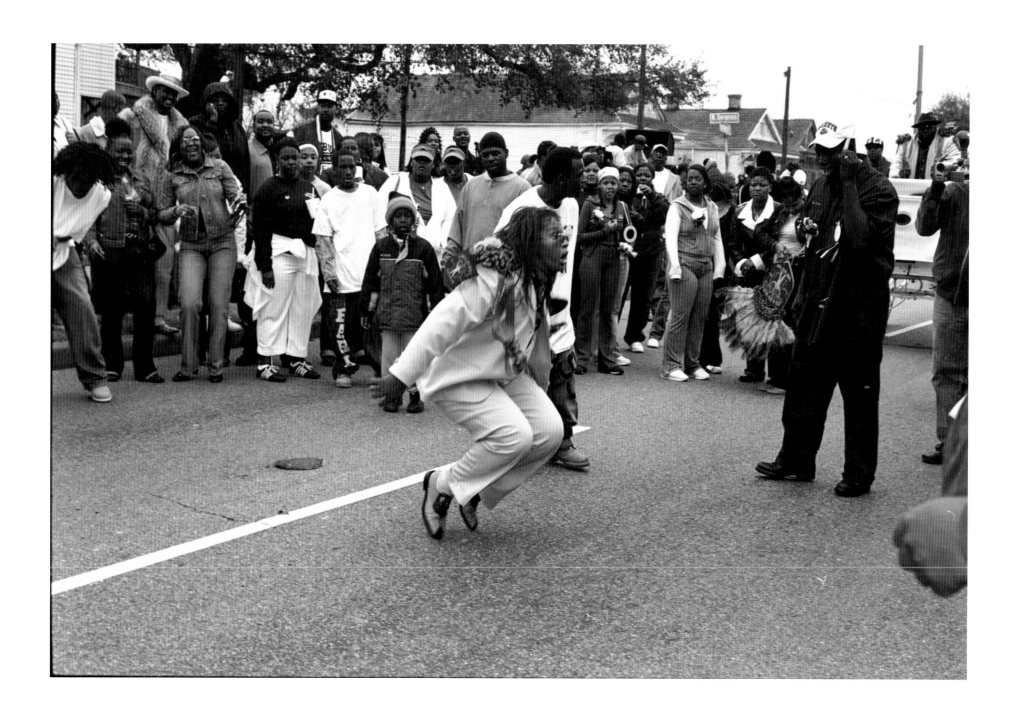

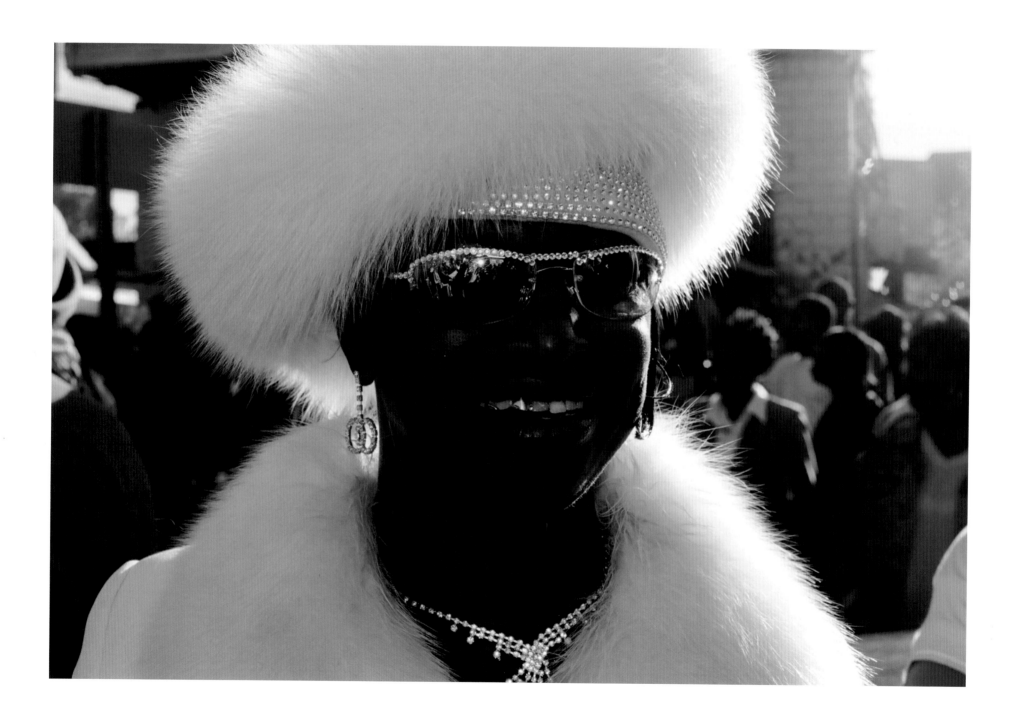

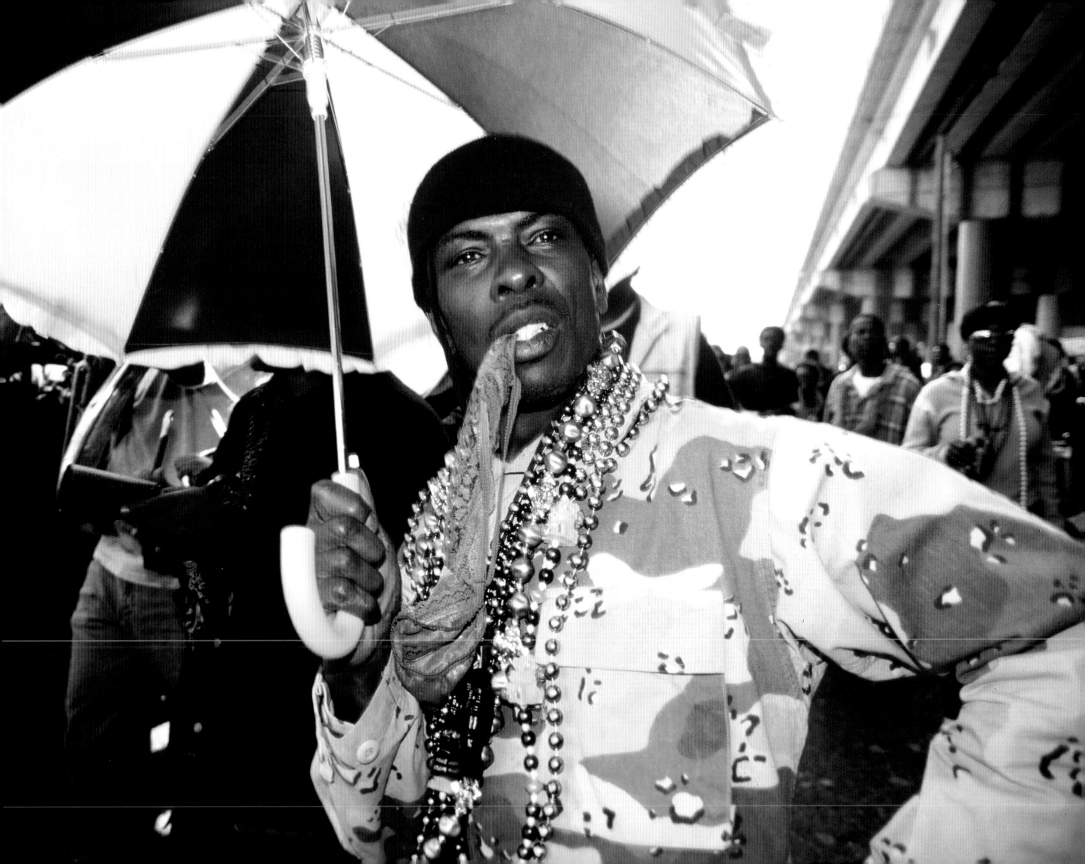

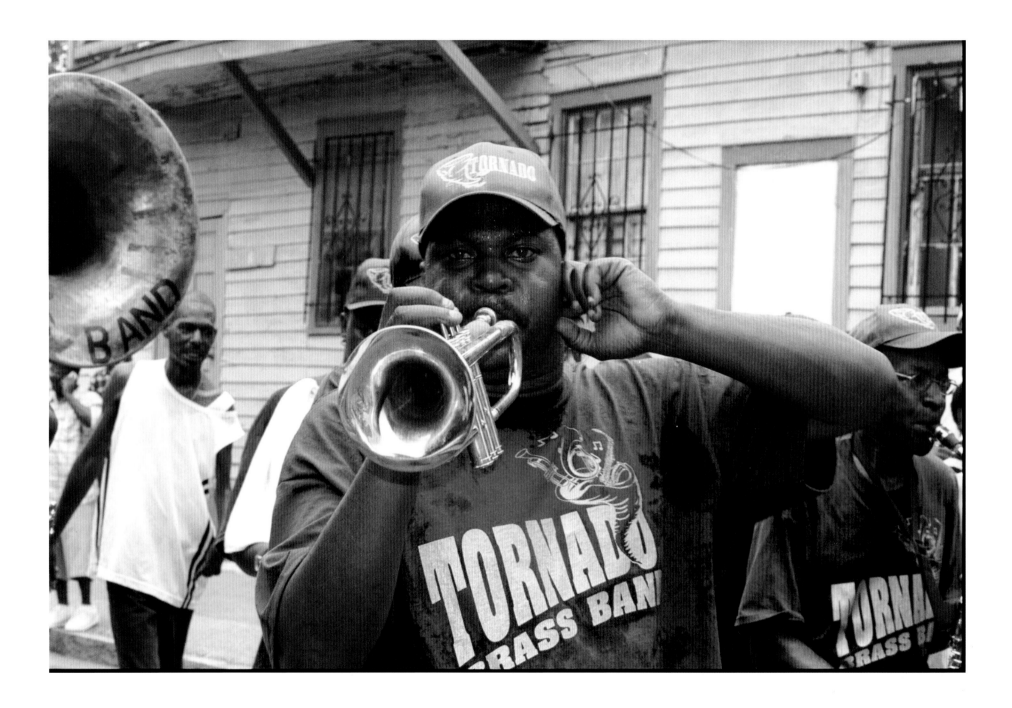

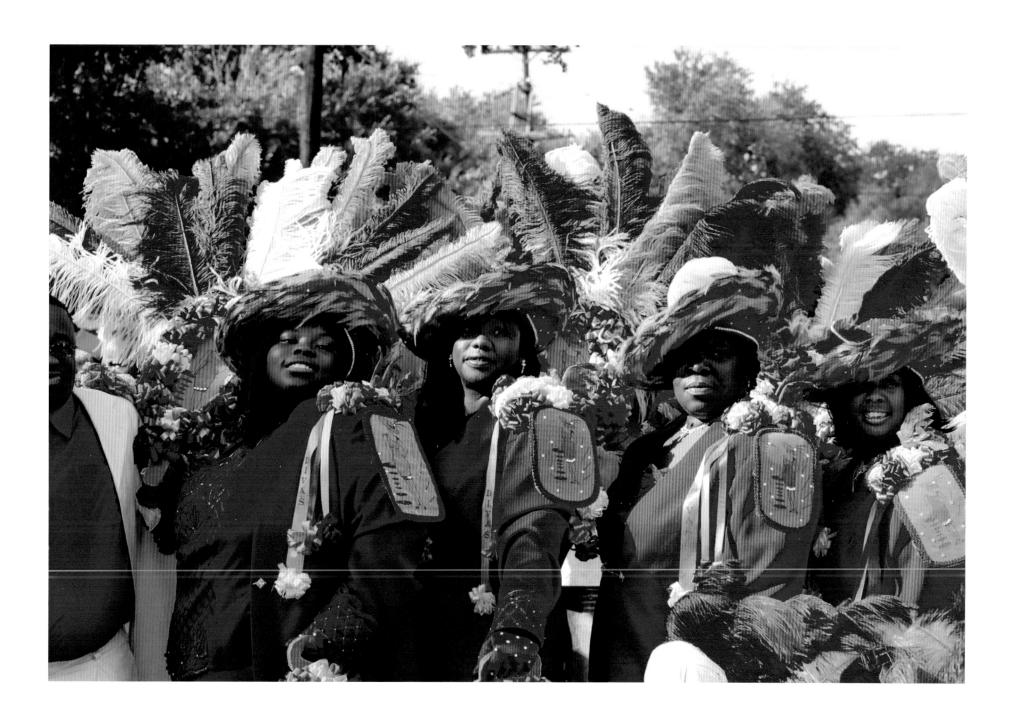

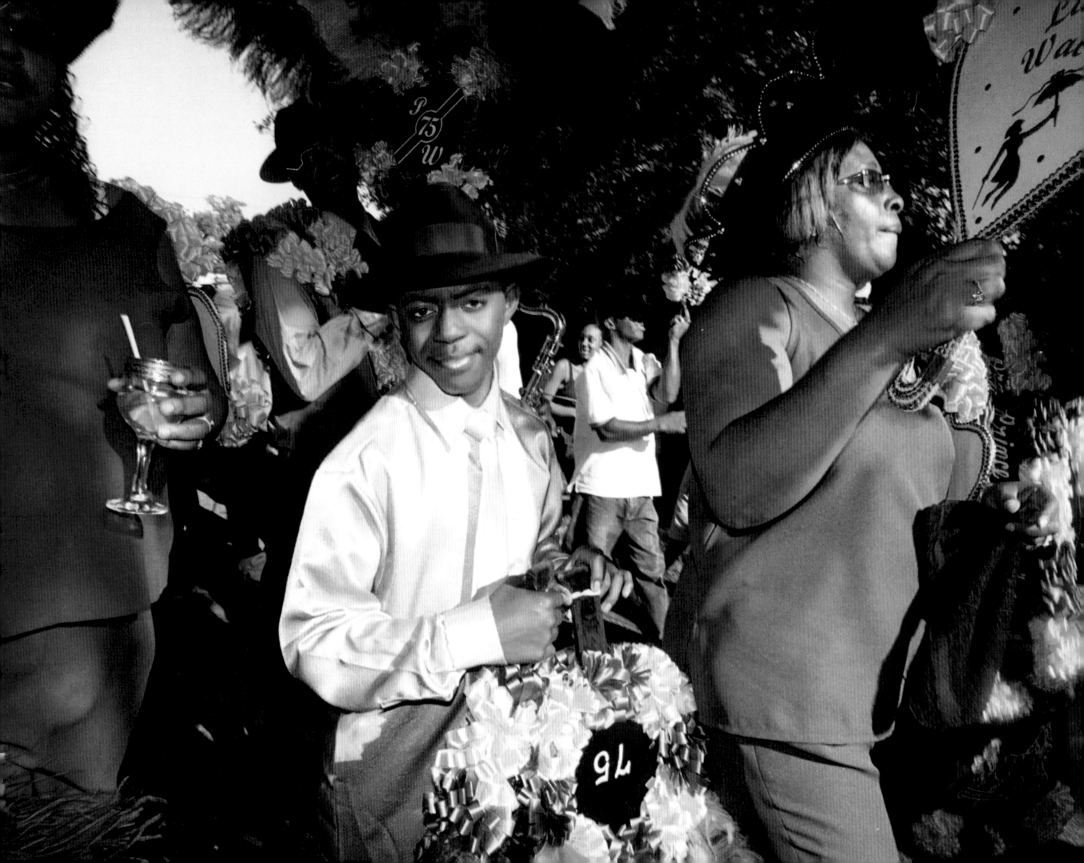

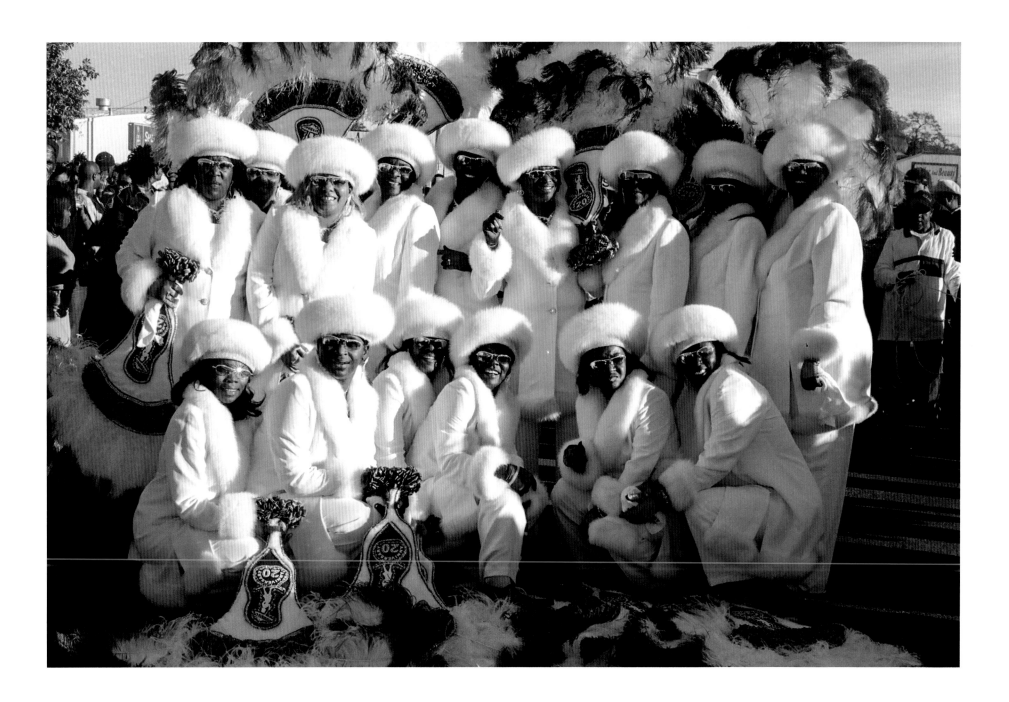

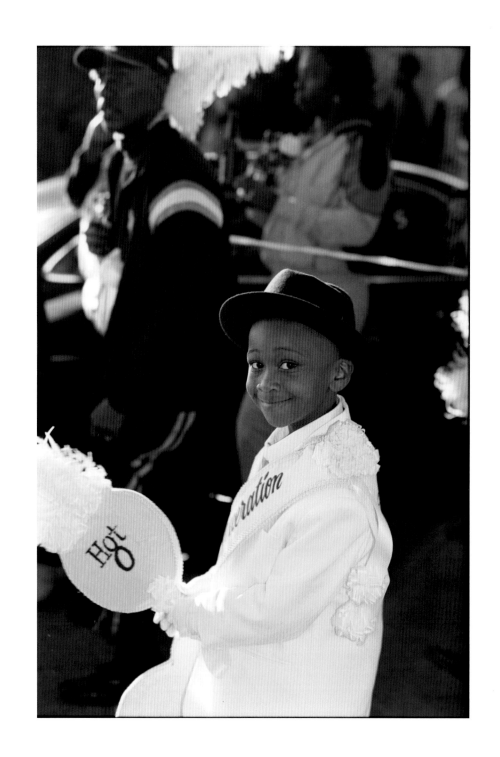

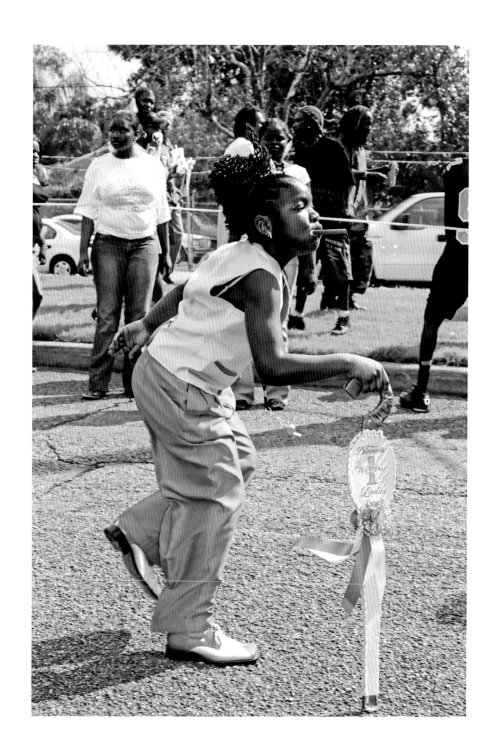

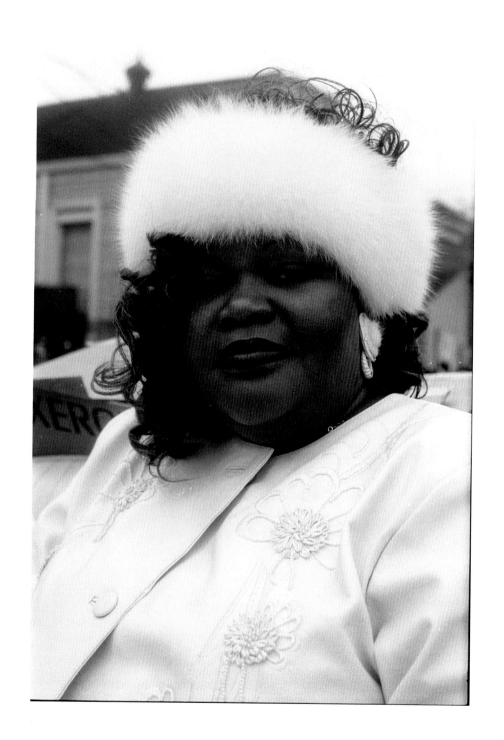

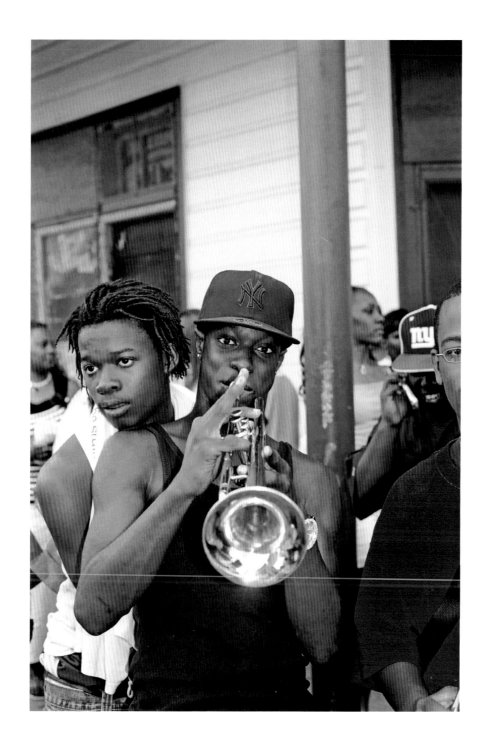

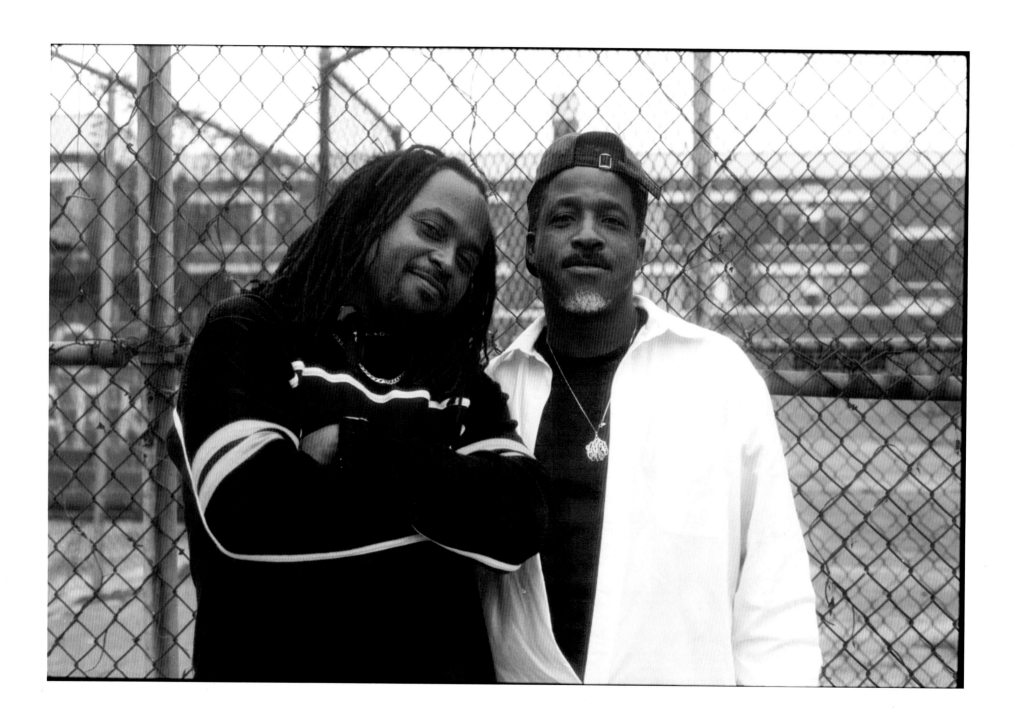

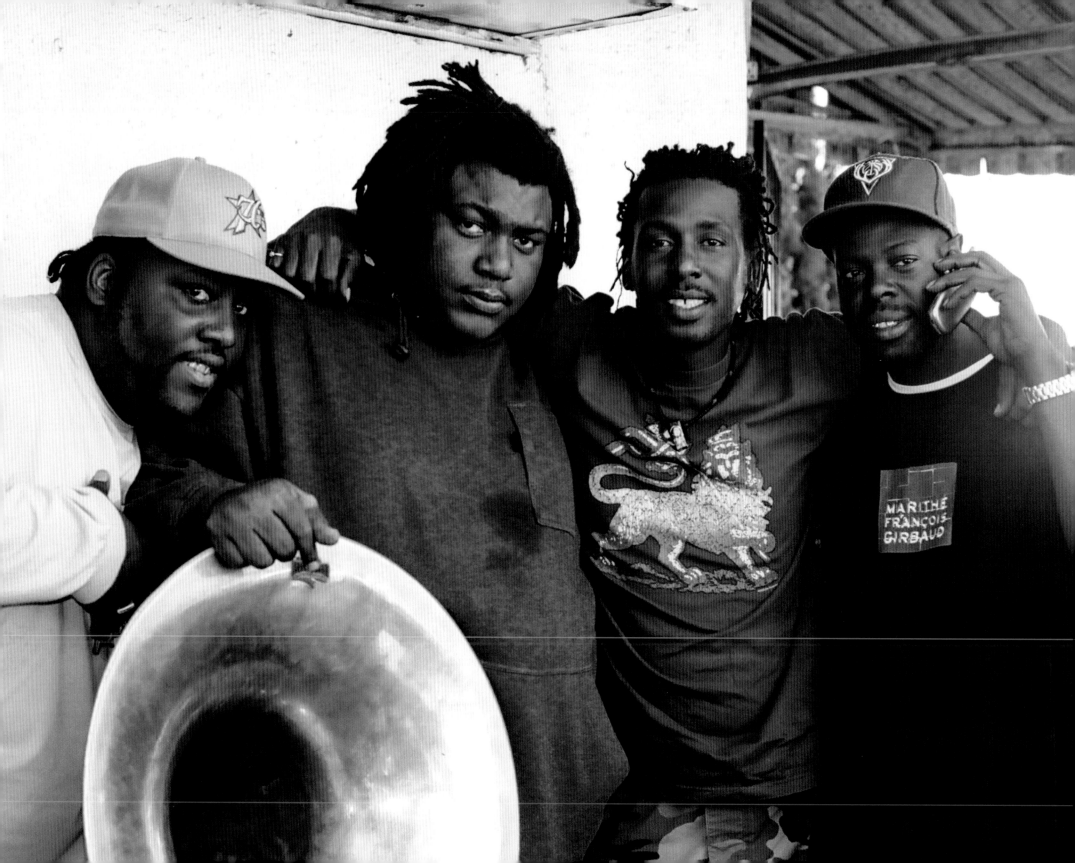

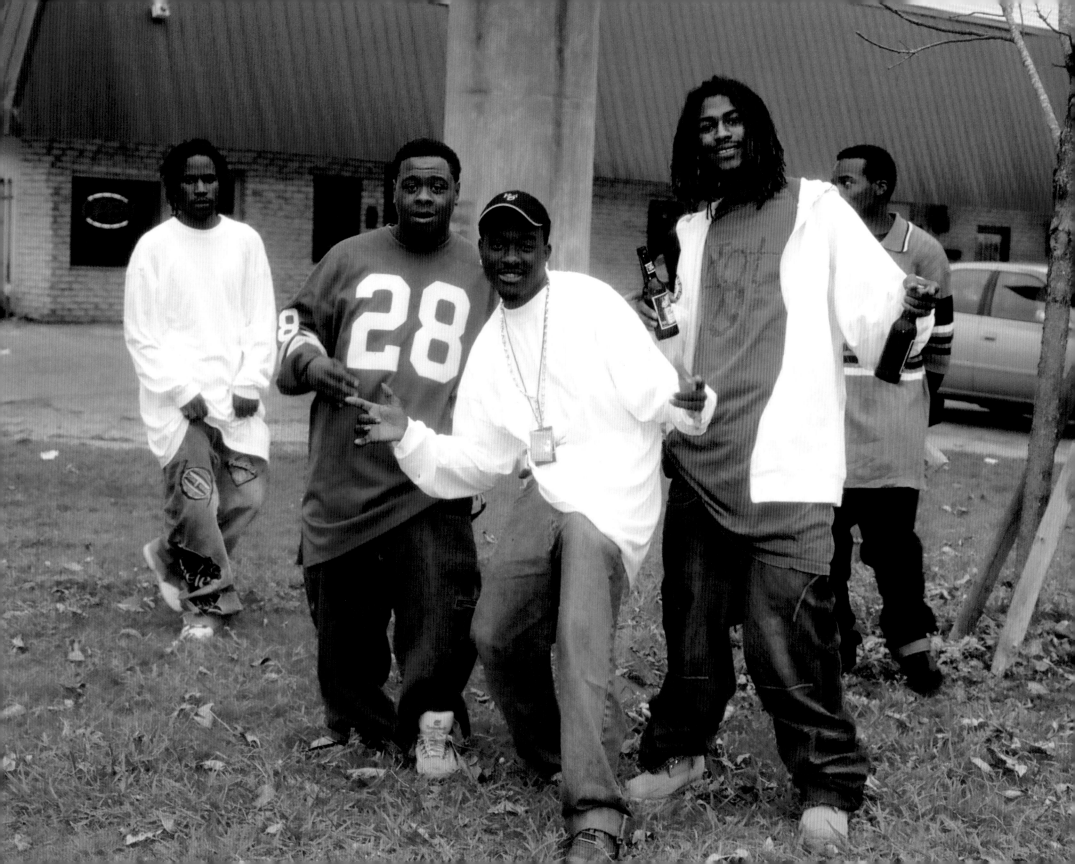

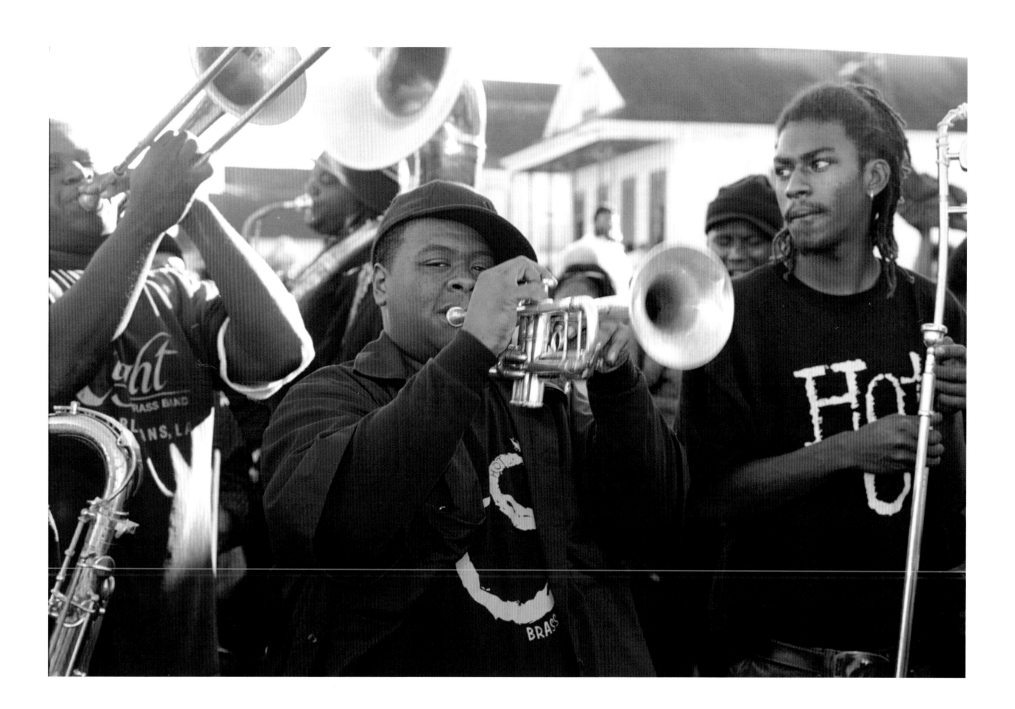

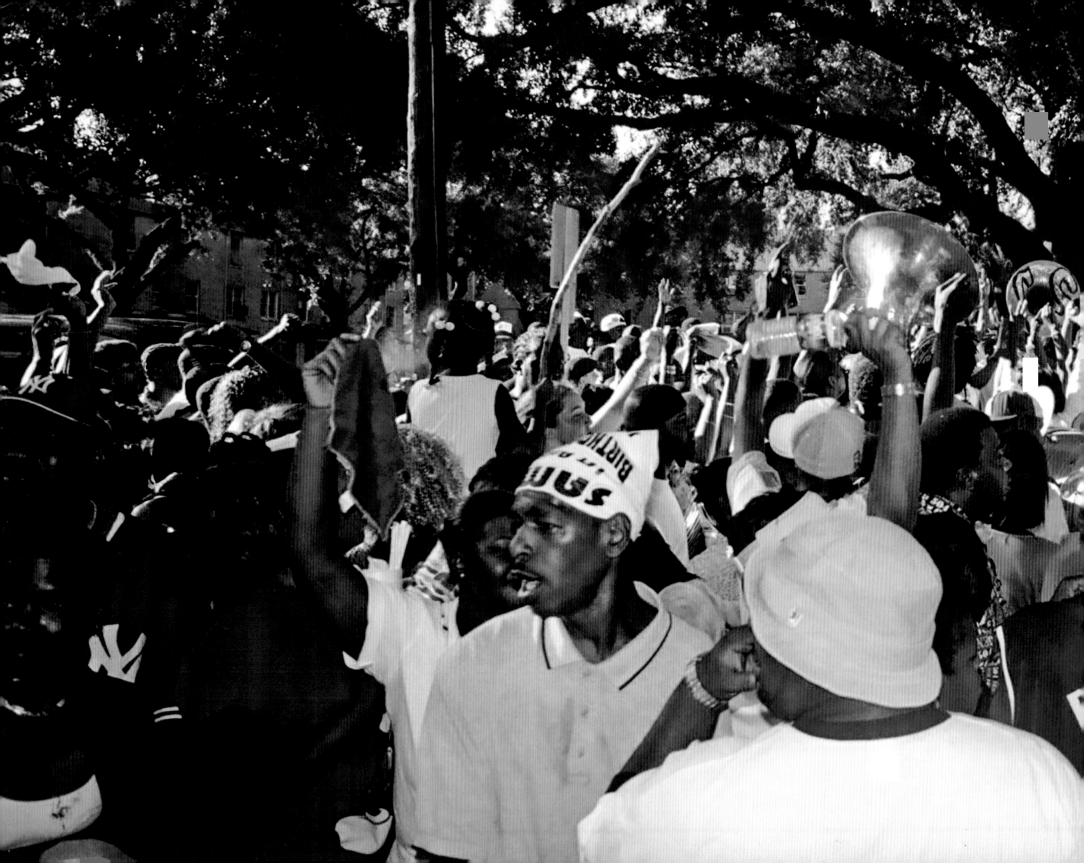

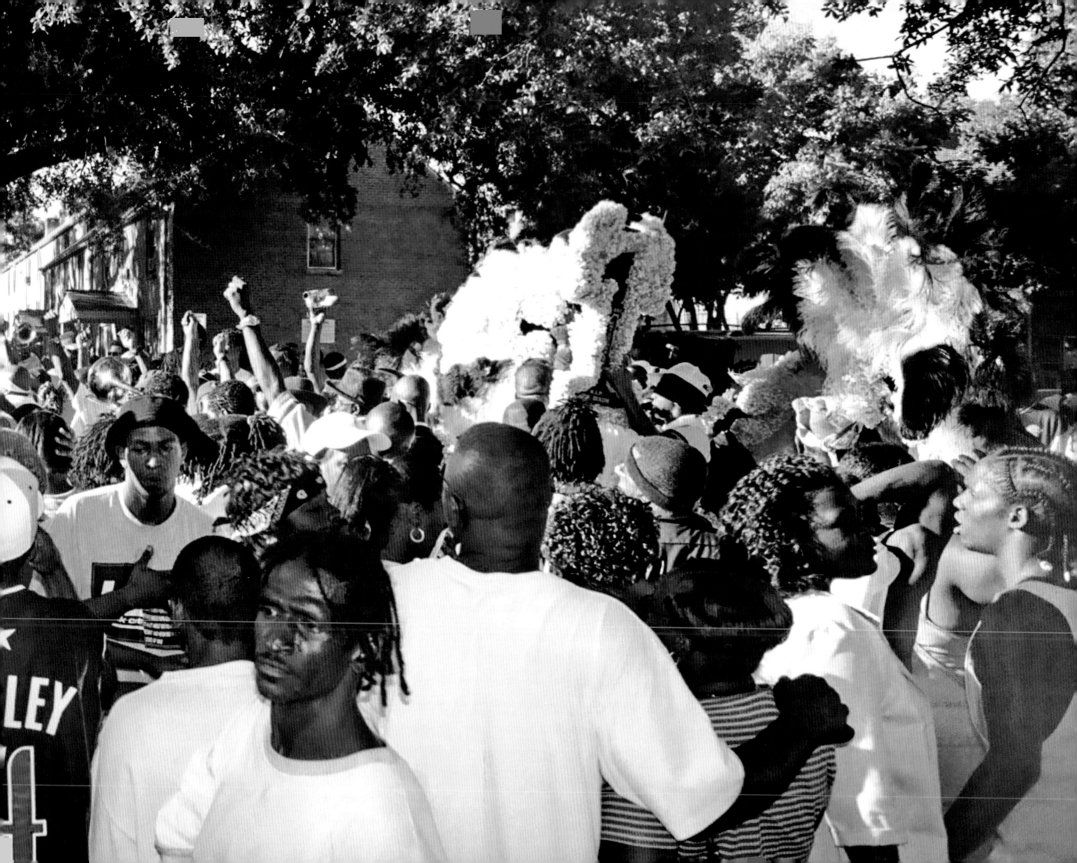

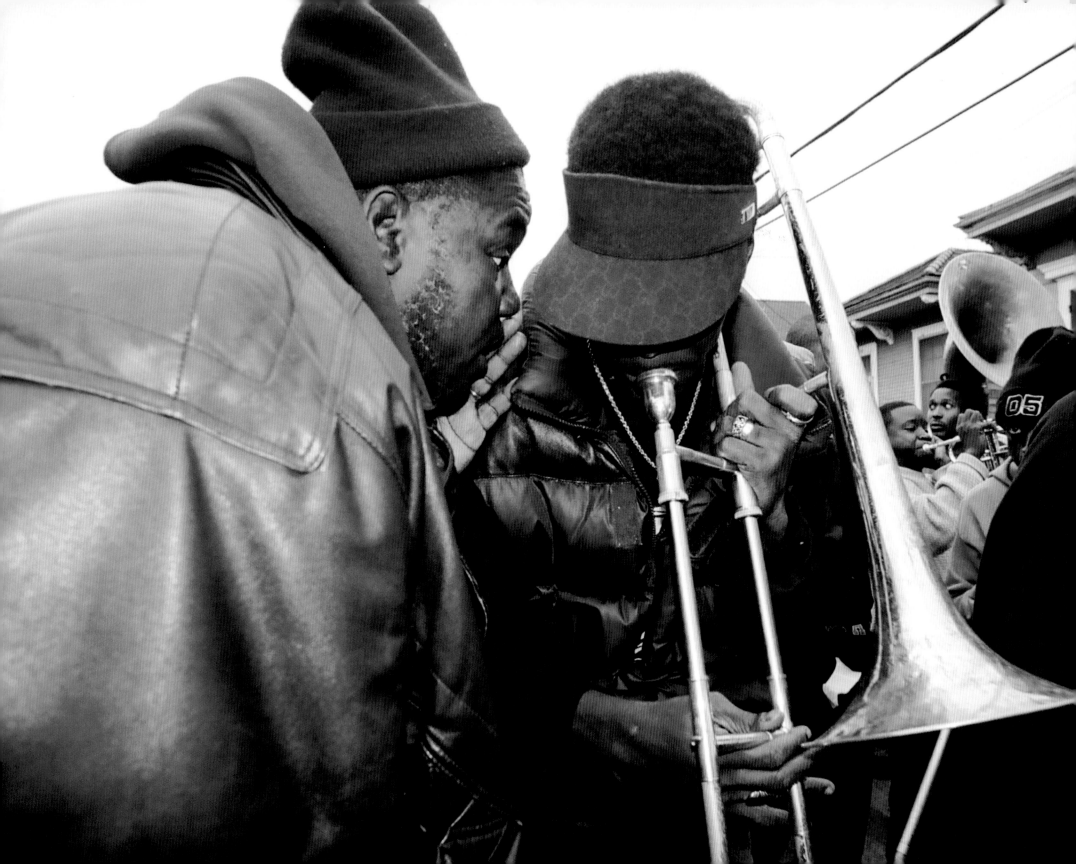

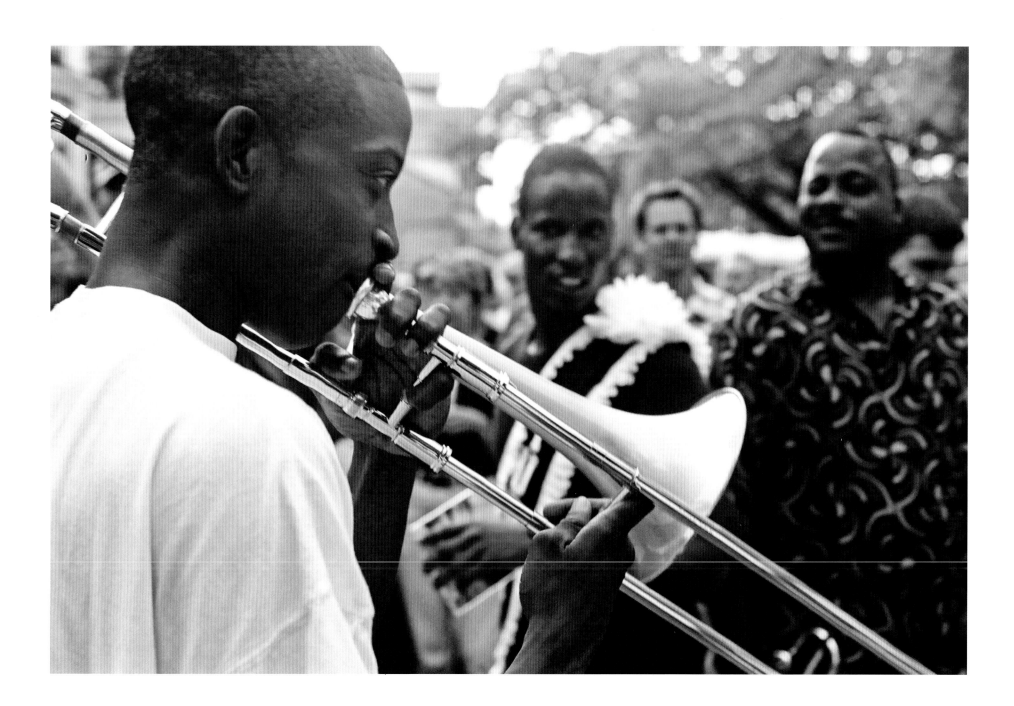

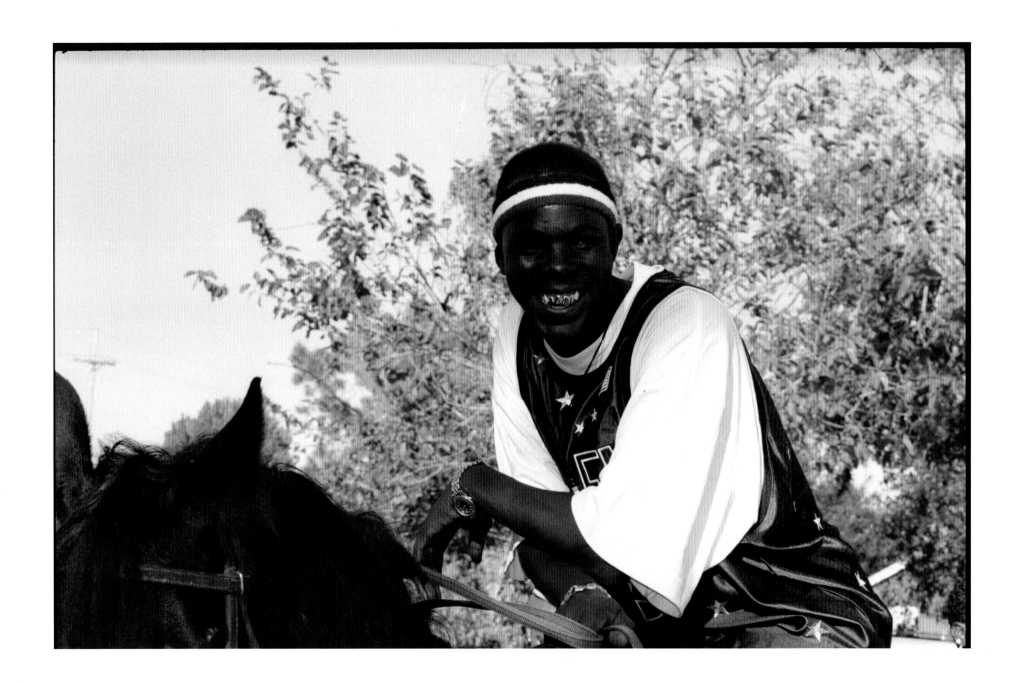

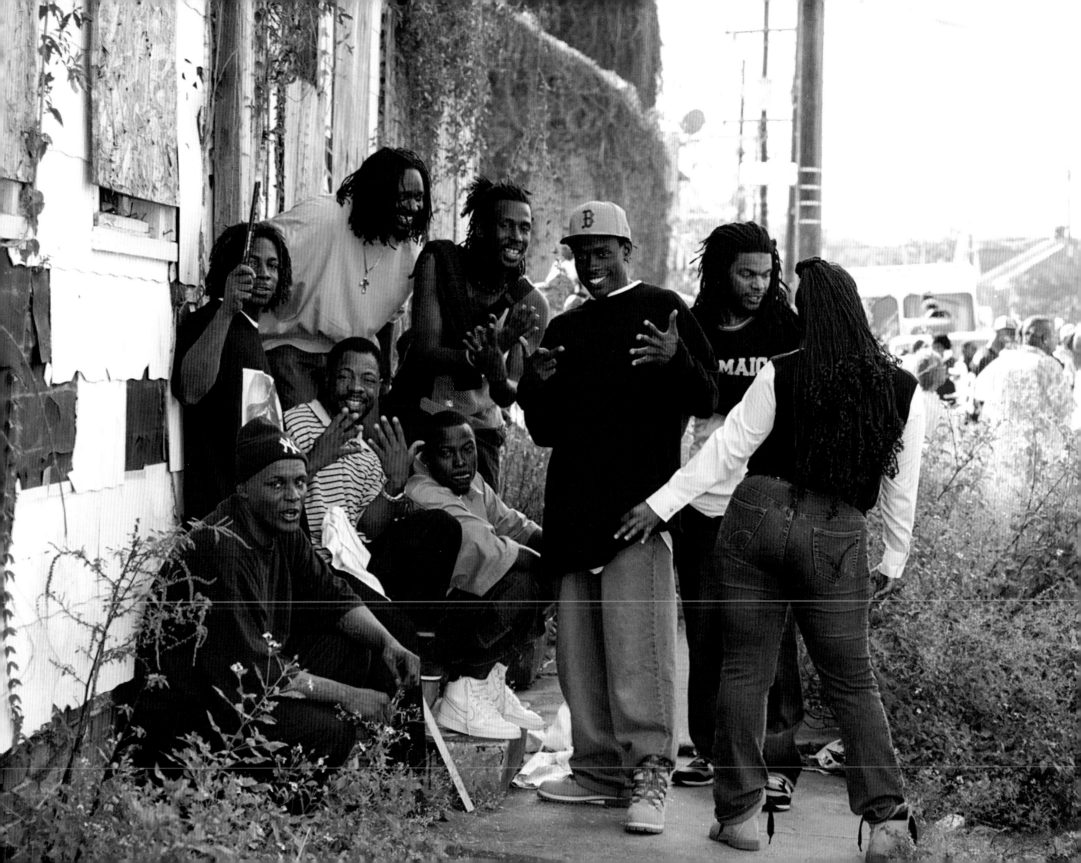

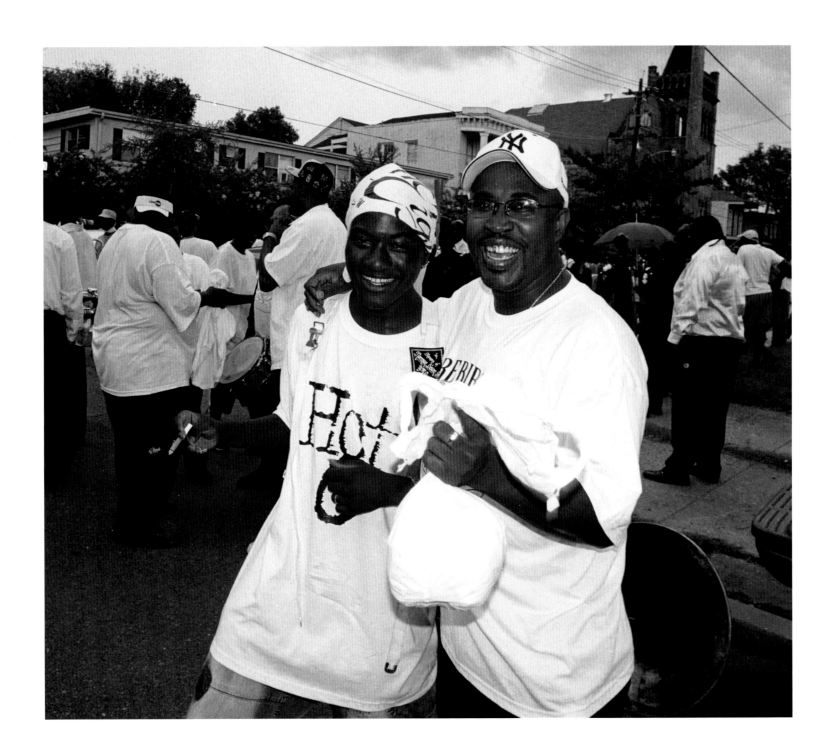

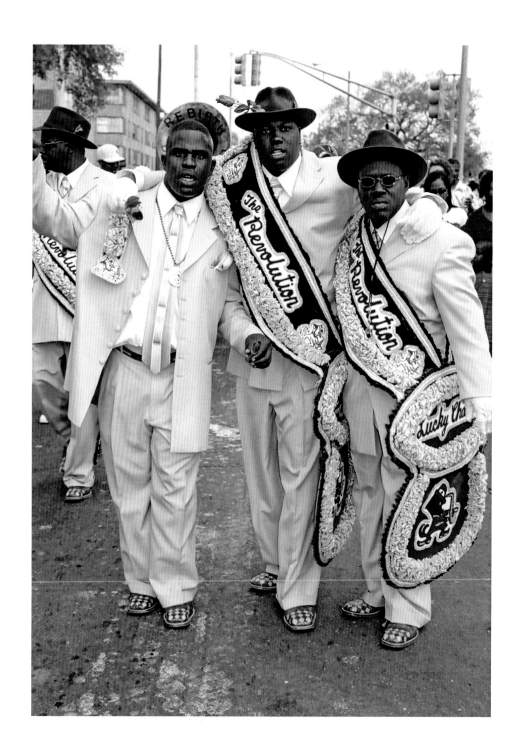

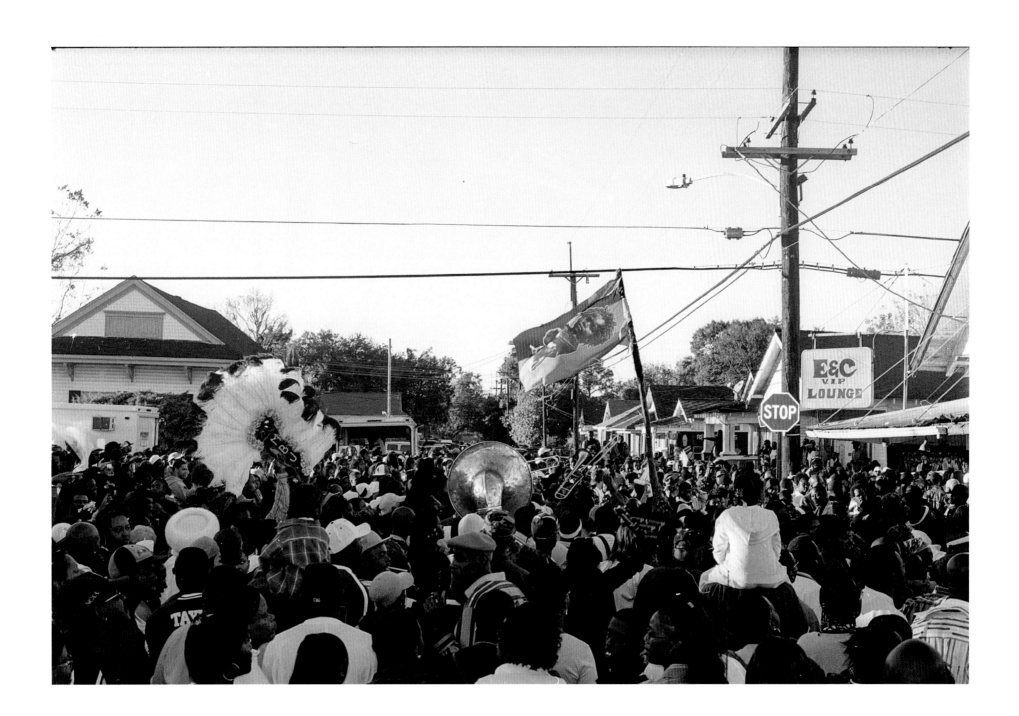

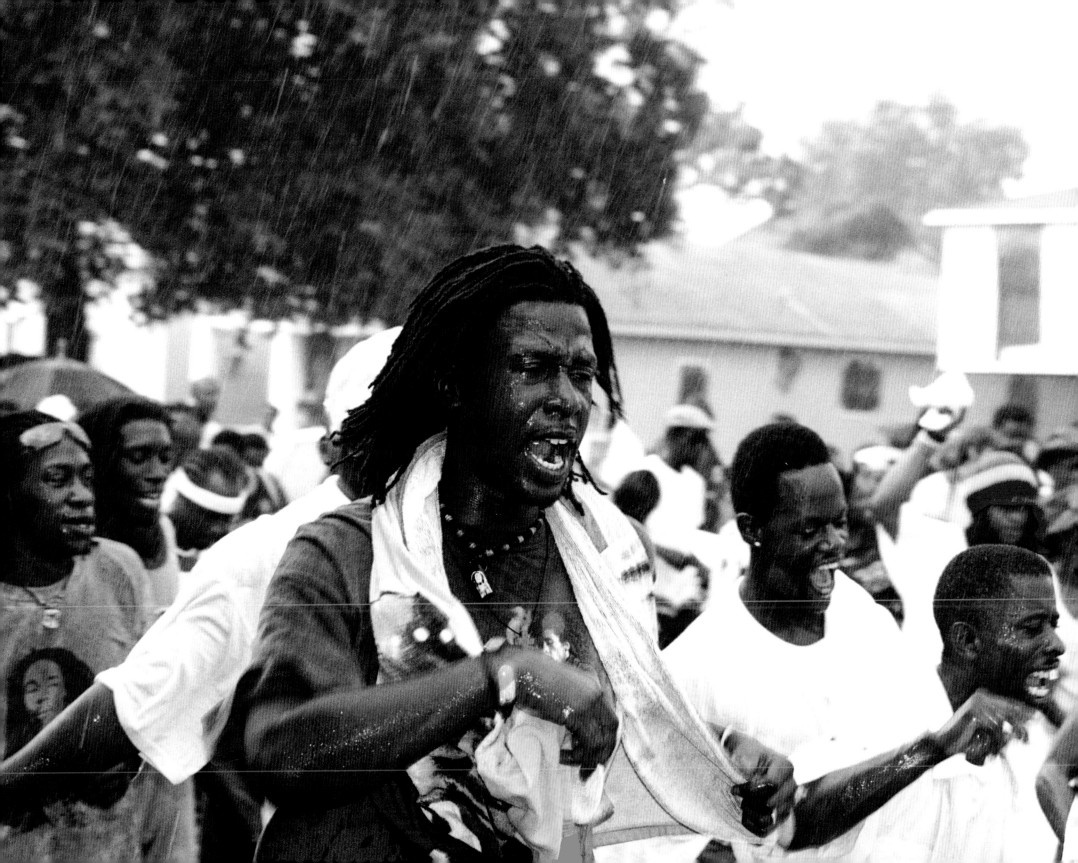

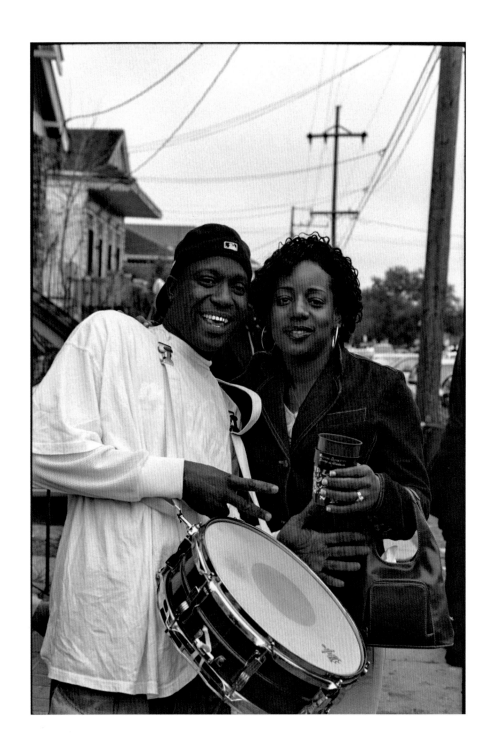

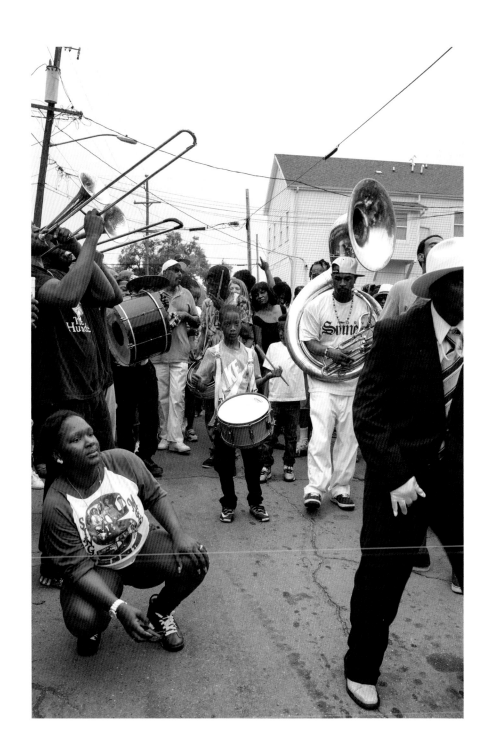

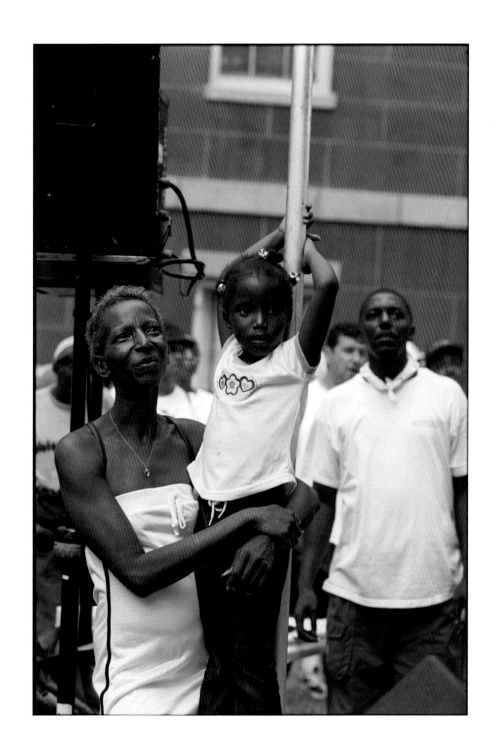

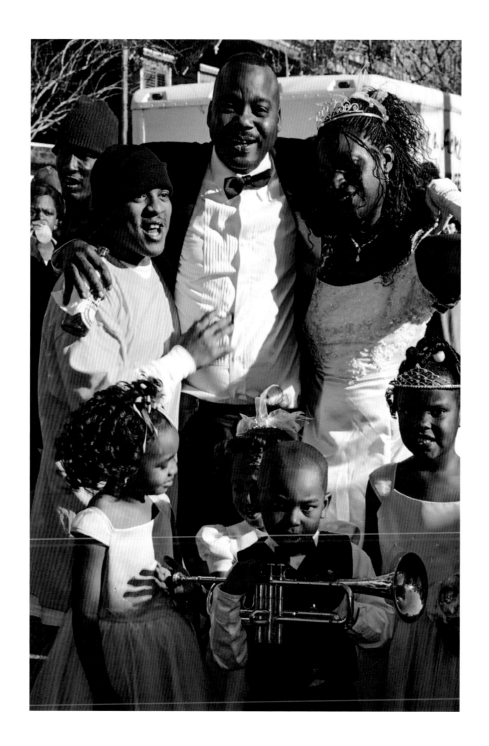

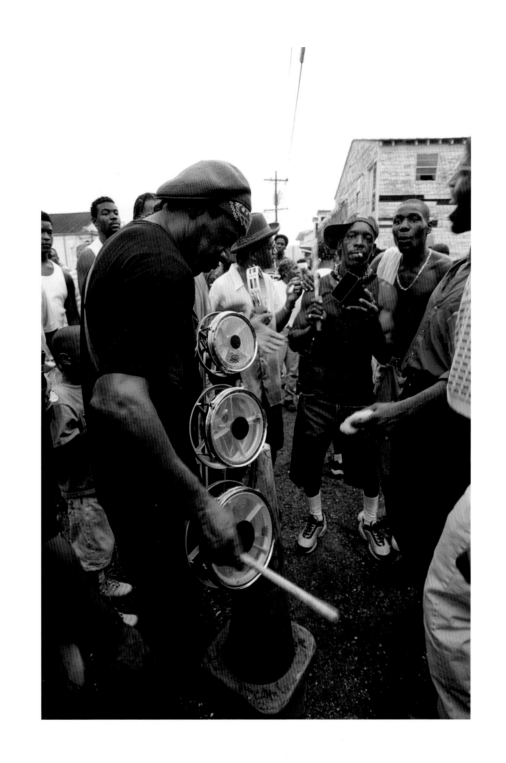

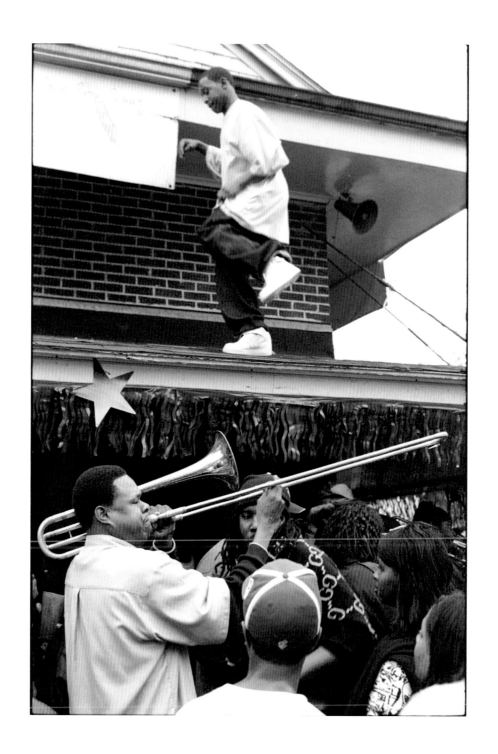

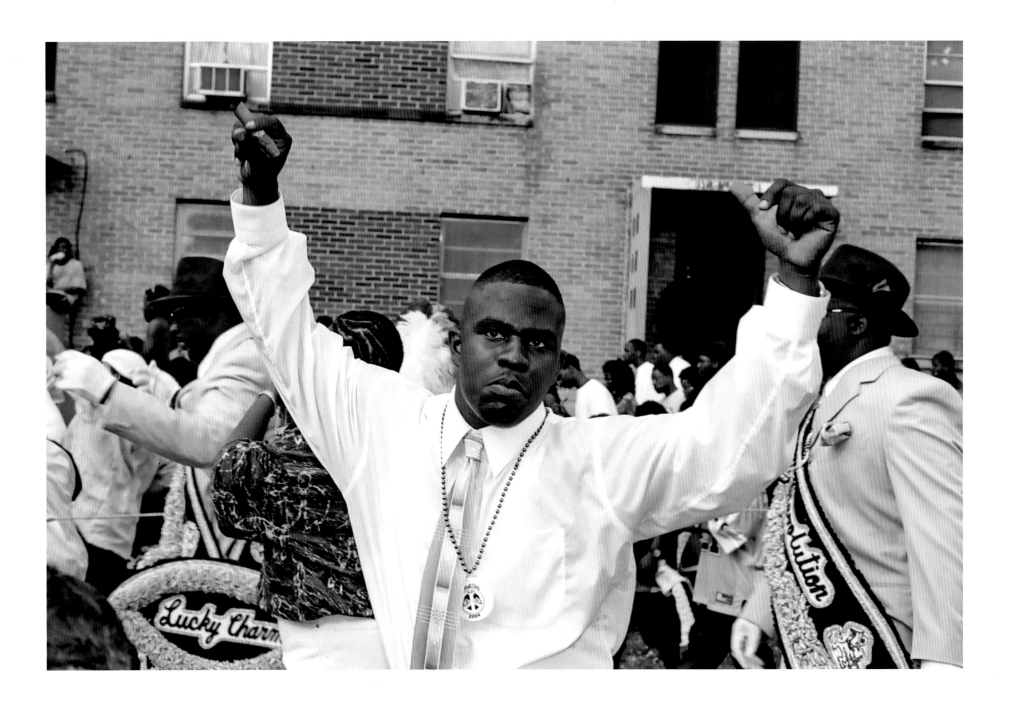

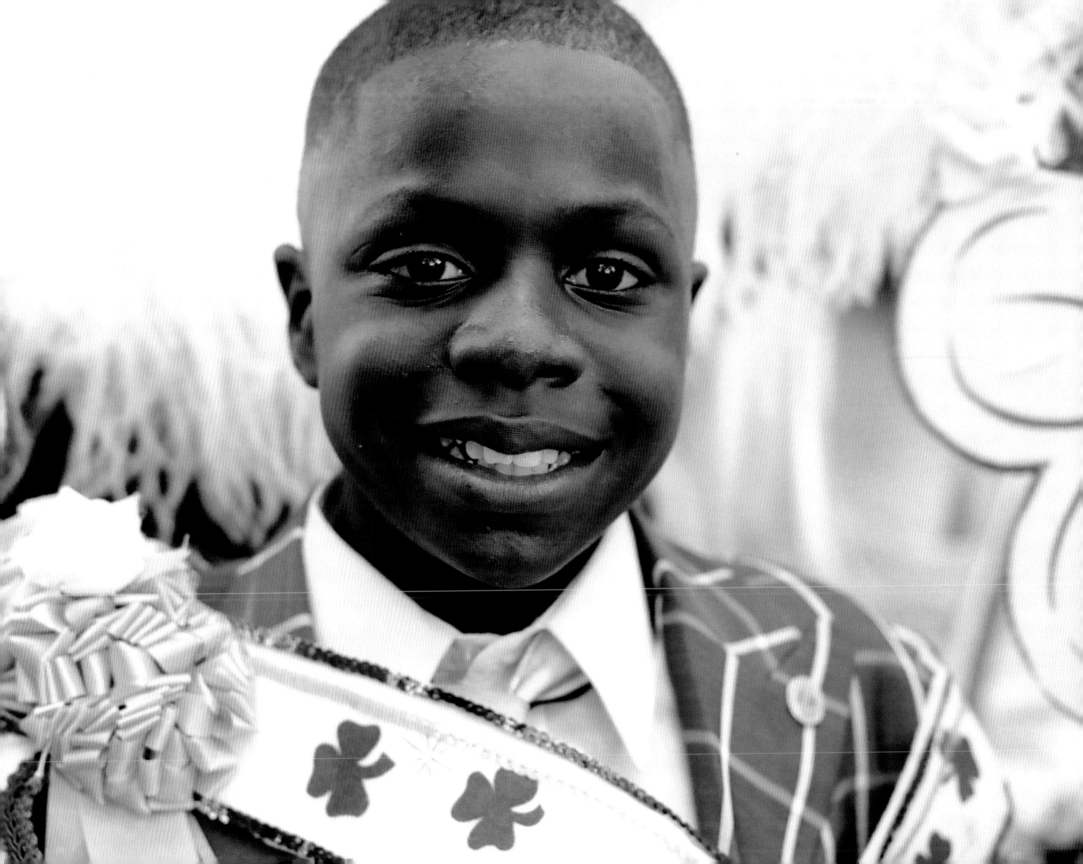

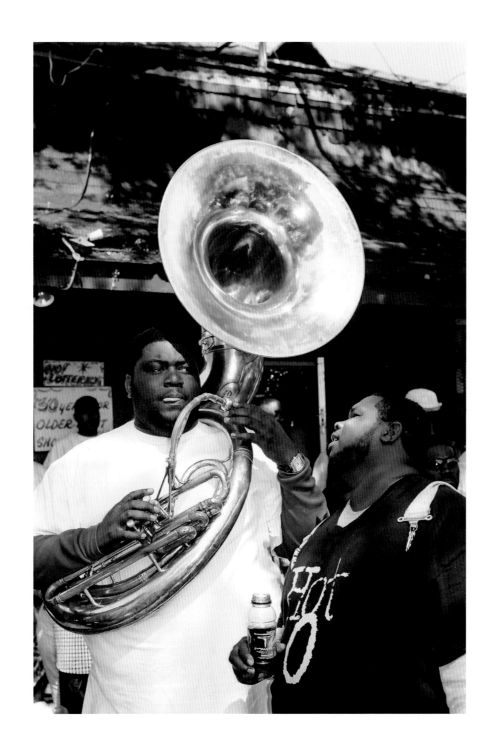

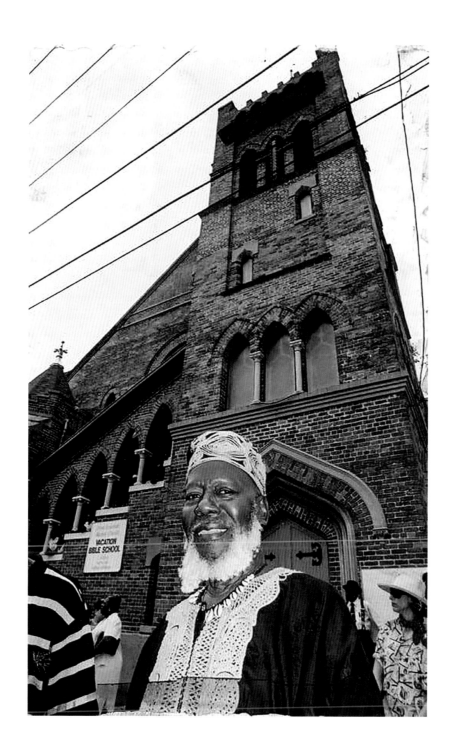

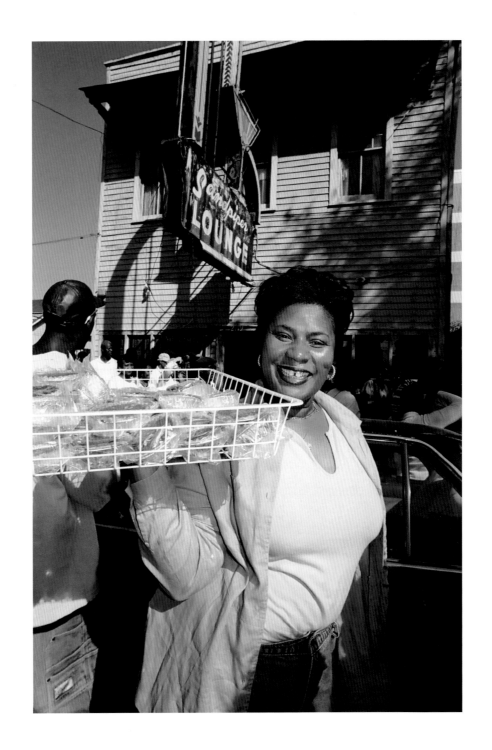

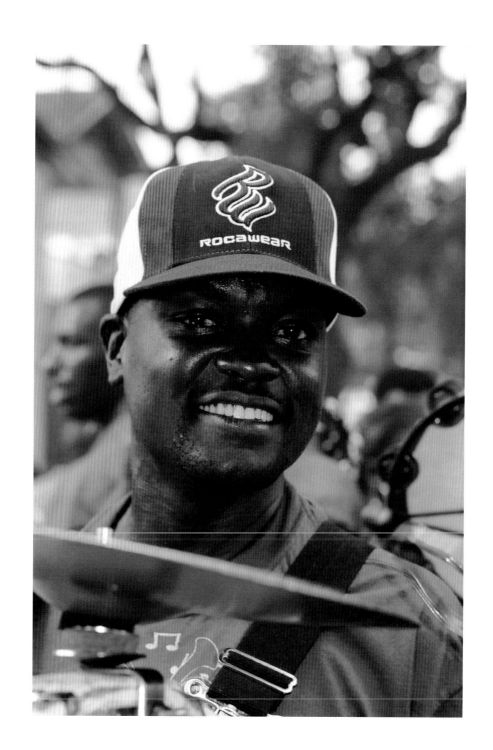

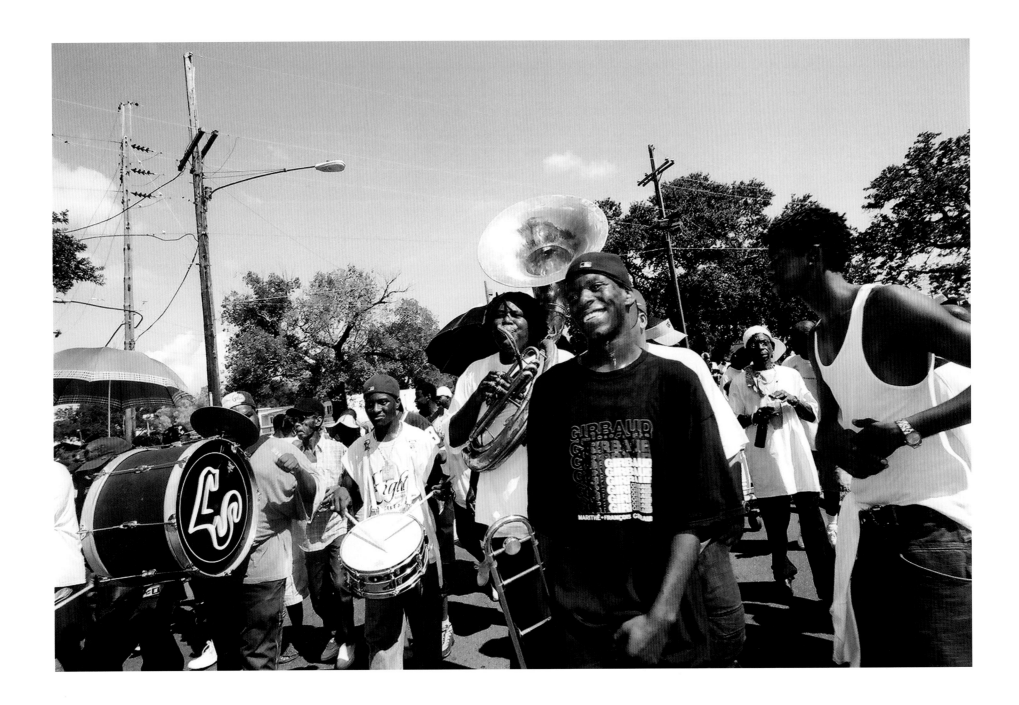

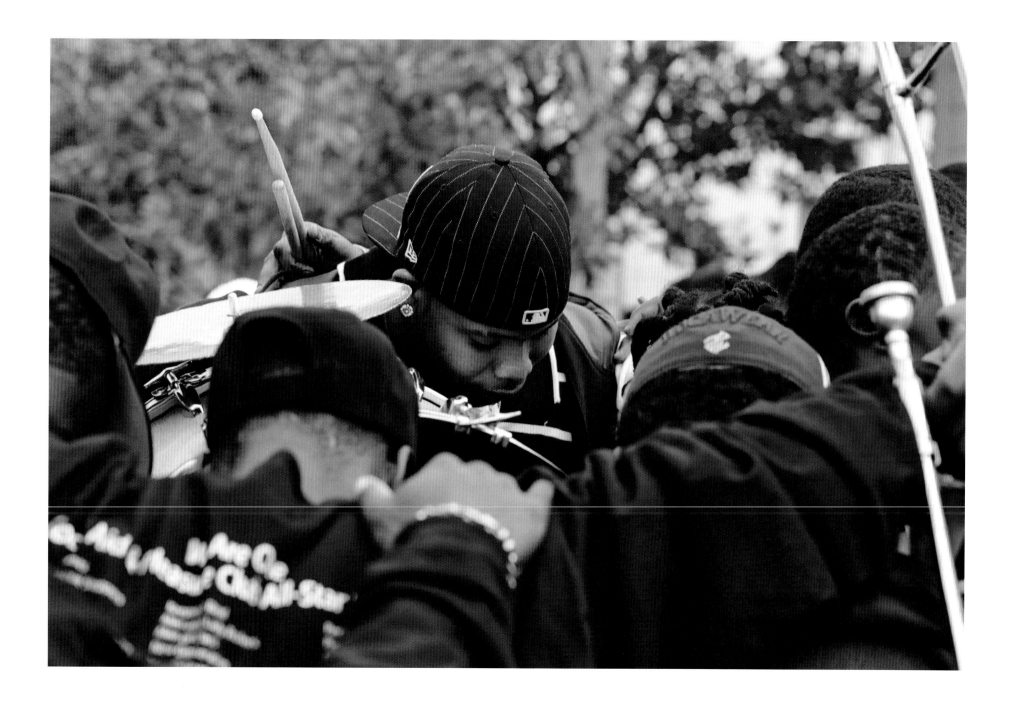

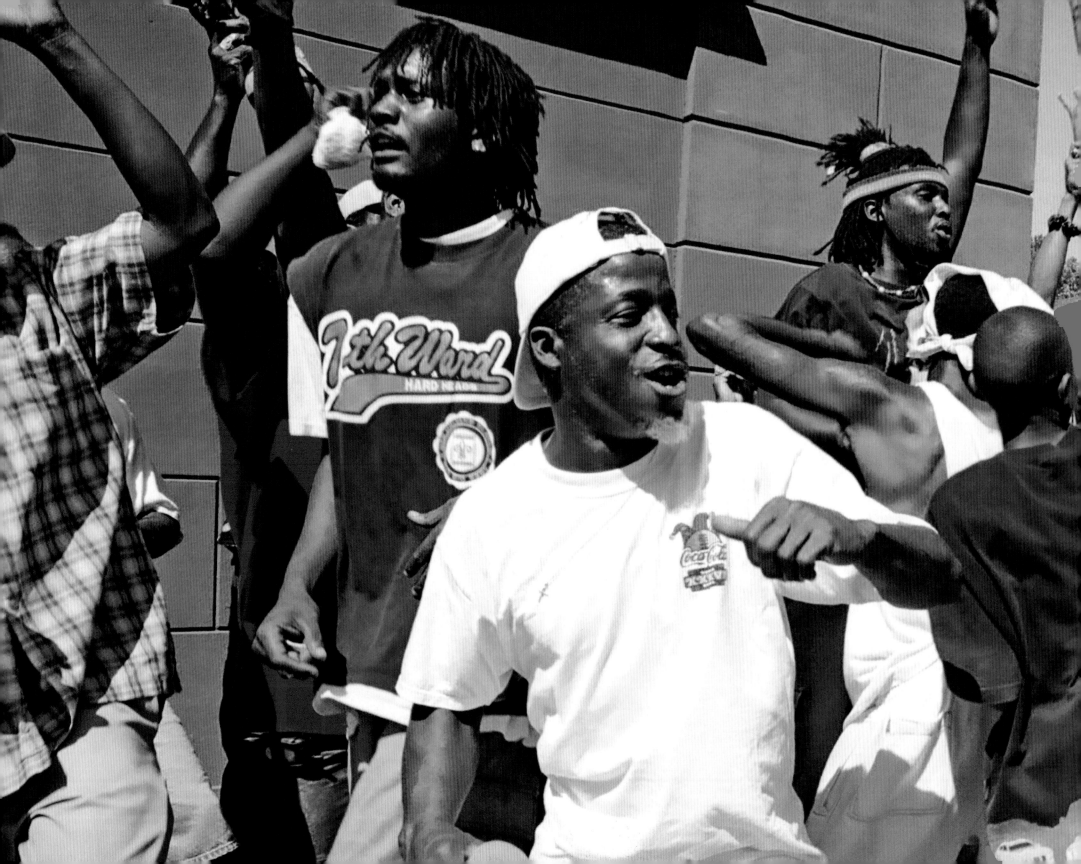

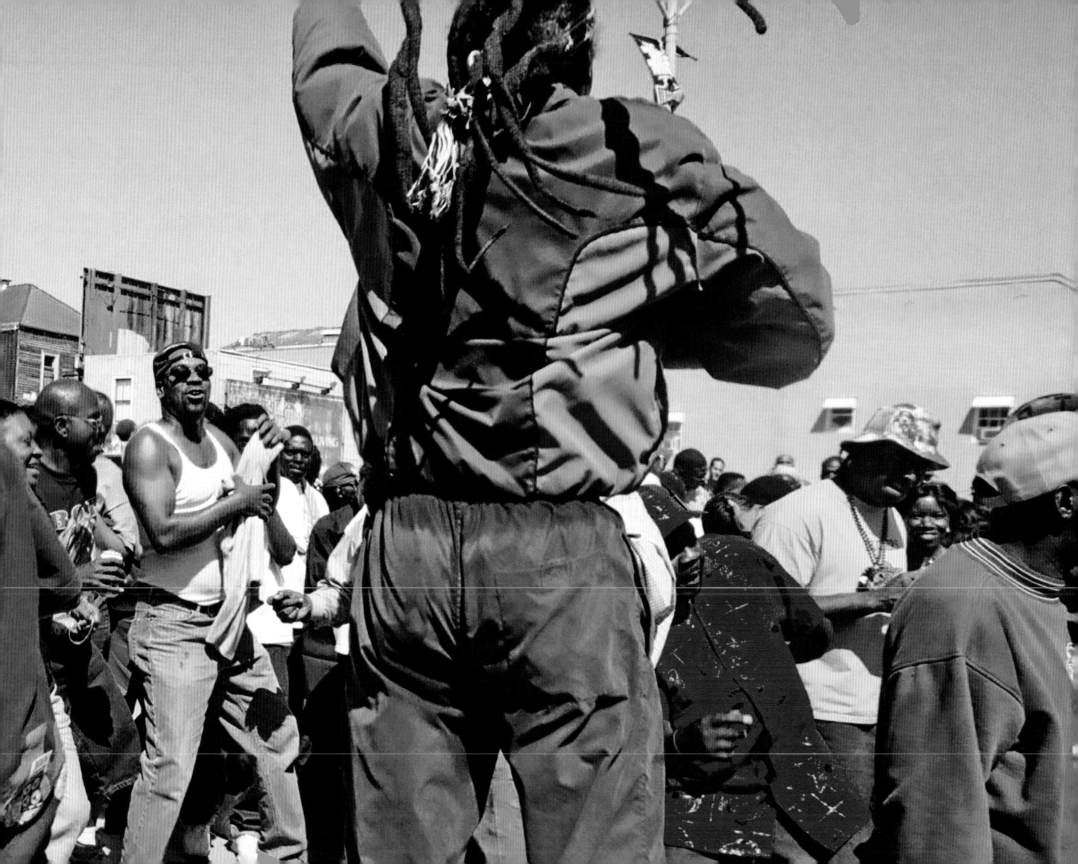

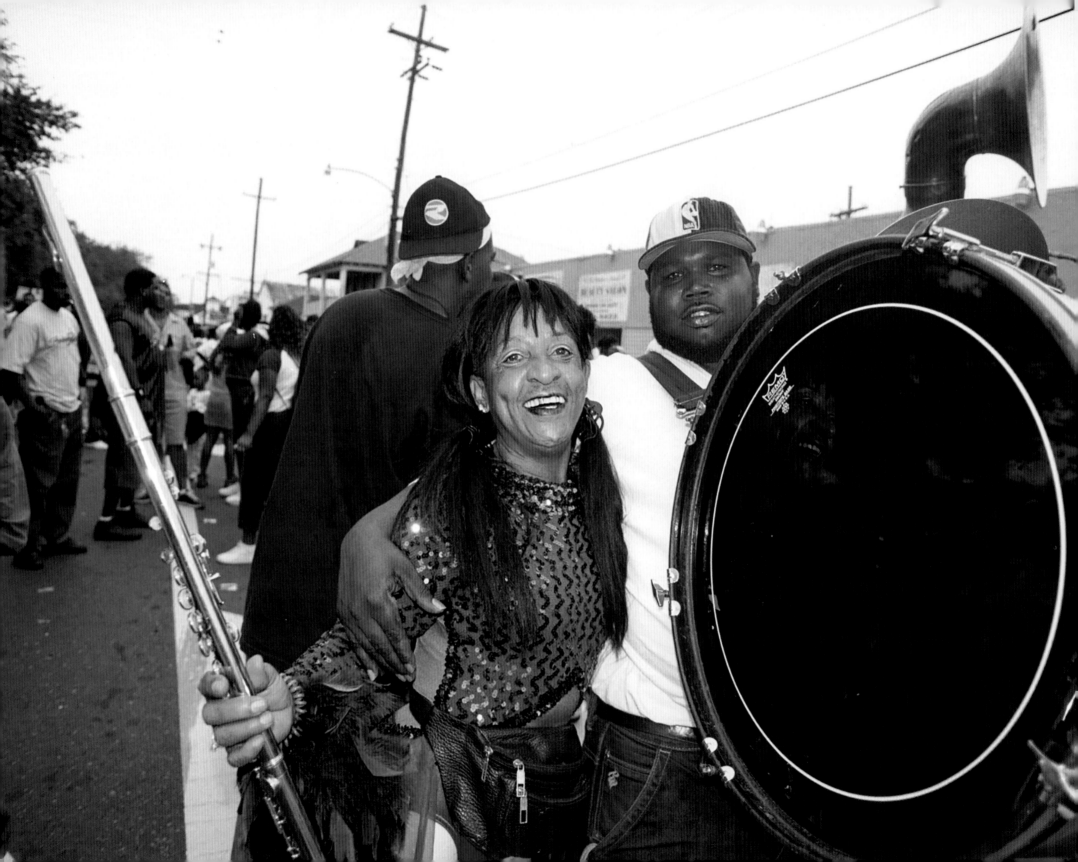

ACKNOW LEDGE MENTS

Jack Marley Riggs • Jose Pool • Iko • Hank • Swayne • Buster • Troy • James • John Kline • Eddie Vanison • Nelson Eubanks • Larry Blumenfeld • Helena • Jada • Fahnlohnee • Bamalee • Jhonu • Kathleen • Jeremiah • Linda • Jonas • Elisha • Linneya • Yeshe • Derrick Freeman • Glen David Andrews • Mario • Emily • Jon Sherman • Andrei Soloviev • Jeannine • Brian Bailey • Wallas • Keng • Michele • Theo • Cree • Oliver Manhattan • Tim and Deb Jorstad • Derrick Tabb • Walter • Lil Rascals Brass Band • Hot 8 Brass Band • Lil Stooges Brass Band • TBC Brass Band • ReBirth Brass Band • Soulja Slim • Kerry Black • Chris Smith • James • Claudia • Jamie • Todd Atkinson • Sam • Johnny • Jenny • Lucy • Susan • Carl • Emma • Jacob • The Mooney's • The Bird's • Jamie Redford • Bob Woodrum and Teri Lang • Polly and Valerie • Selma Lewis • David Hilliard • Dan Tague • Mary T • Cherie Dominic • Sally Roberts • Isobel Barbara Lynn • Jenny Bagert • Herman Leonard • Jon Cedric • Chris Lane • Nobu Ozaki • Joshua Cohen • Jeff Demain • Toad • Matt • Bruce • Iris • Pete • Frenchy • Jamie • Muffin • Stephanie • Philip • Shane • Joe • Rudy and Diane • Sue • Joe • Rose • May • Gail Keifer • Becky • Spencer • Rio Del Valle • Alex McMurray • Laura Tennyson • Lee Frank • Mick Vovers • Jacques Leonardi • Larry Feeney • Birney Imes • Ming • Dave and Lily • Doug Frost • Vartan • Shizuka • Hannah • Andy • Avery • Edgar • Rachael • Tori • Francesca • Kia • Kit • Henry • All the Second Line and Social and Pleasure Clubs • All Good in the Hood • Celeste Phillips • Varonica and Luke • Stacie and David • Juvenile • Juggie • Terrence Sanders • Michelle Mongan • Magnus and Mary Lou

MICHELLE L. ELMORE CV

EDUCATION

- Mississippi University for Women, Columbus, MS 1988-1992
- Self-taught Photographer

SOLO EXHIBITIONS

- Henry Miller Library, Big Sur, CA, 2004
- Mississippi University for Women, Columbus, MS 2002
- Fantastic Stories, Jonathon Ferrara Gallery, New Orleans, LA, 2001
- Henry Miller Library, Big Sur, CA, 2000

GROUP EXHIBITIONS

- Katrina's Wake, New Orleans Museum of Art, New Orleans 2006
- Straight out of NOLA...The Mardi Gras Indians, Ashville, NC 2006
- After the Storm, New Orleans, LA 2006
- Finding Our Folks, Jackson MS, 2006
- Arts at Michigan, University of Michigan, Ann Arbor, MI 2006
- Atypical Portraiture, Barrister's Gallery, New Orleans, LA 2006
- Surge New Orleans on High Ground, Brooklyn NY, 2006
- In Harm's Way, Lower Manhattan Cultural Council, NYC 2006
- Paradise Lost, Frederieke Taylor Gallery, NYC, 2006
- No Place Like Home, Giola Gallery, Chicago, IL Nov. 2005
- Halloween NYC with the Hot 8 Brass Band 2005
- Museum of Natural History, London, England 2005
- Femme Fatale Ball, New Orleans, 2005
- Michelle Elmore and John Waters, Aurther Rodger Gallery, New Orleans, LA, 2002
- Second-Line Sundays, Frenchy Gallery, New Orleans, LA, 2002
- Entergy Louisiana Open, Contemporary Arts Center, New Orleans, LA, 2001
- Nude vs. Nude, Jonathon Ferrara Gallery, New Orleans, LA, 2001
- Art Doc's, Vaqueros, New Orleans, LA, 2001
- Fool's Fest, Hopscotch in the City, New Orleans, LA, 2000
- No Dead Artist, New Orleans, LA, 2000
- Super-Heroes, Three Ring Circus, New Orleans, LA 2000
- Virginia Highlands 51st Annual Photography Exhibit, 1999
- F.A.V.A., Oberlin, OH, 1997

PUBLIC COLLECTIONS

- Museum of Natural History, London, England 2005
- New Orleans Museum of Art, New Orleans, LA, 2003, 2004, 2006
- Mississippi Museum of Art, Jackson, MS, 2003
- Mississippi University for Women, Columbus, MS, 2002
- Xavier University, New Orleans, LA, 2002
- Backstreet Cultural Museum, New Orleans, LA, 2001

PUBLICATIONS

- Atypical Portraiture, Chopper, 2006
- My Knee Will Bend No More, New Orleans, LA 2005
- Mister Motley Idealin, Amsterdam Fine Art magazine 2005
- The History of Diamonds, The Natural History Museum, London, 2005
- Millennium Photo Project, 2000
- Art Review/ Gambit Weekly 2002
- Monterey County Weekly, 2004
- Best of New Orleans, 2001
- Contemporary Art Center Visual Arts Publication for Entergy Louisiana Open 2001
- Fantastic Realities, Gambit Weekly, 2000
- The Times-Picayune, 2000
- WWOZ, No Dead Artist, 2004
- Easy Jet In-flight Magazine, London, England, 2004
- Chili Chili, London, England, 2005
- Squeeze, Amsterdam, 2004

HONORARIUMS AND TEACHING POSITIONS

- New Orleans Left Behind, Documentary on the New Orleans public school system, still photographer 2004-2007
- Contemporary Art Center, Louisiana Open, Best emerging Artist in New Orleans, LA 2001
- Fresno inter-city youth mentoring 1996
- New Orleans inter-city youth mentoring 2000-2003
- Guest Speaker, Mississippi University for Women, 2002

STAND STILL LIKE THE HUMMINGBIRD

HENRY MILLER

02.16.1962

California

The artist — I employ the term only for the genuine ones — is still suspect, still regarded as a menace to society. Those who conform, who play the game, are petted and pampered. Nowhere else in the world, unless it be in Soviet Russia, do these conformists receive such huge rewards, such wide recognition for their efforts.

So much for the dominant note. As for the subdominant, the thought is — don't wait for things to change, the hour of man is now and, whether you are working at the bottom of the pile or on top, if you are a creative individual you will go on producing, come hell or high water. And this is the most you can hope to do. One has to go on believing in himself, whether recognized or not, whether heeded or not. The world may seem like hell on wheels —and we are doing our best, are we not, to make it so? — but there is always room, if only in one's own soul, to create a spot of Paradise, crazy though it may sound.

When you find you can go neither backward or forward, when you discover that you are no longer able to stand, sit or lie down, when your children have died of malnutrition and your aged parents have been sent to the poorhouse or the gas chamber, when you are convinced that all the exits are blocked, either you take to believing in miracles or you stand still like the hummingbird. The miracle is that the honey is always there, right under your nose, only you were too busy searching elsewhere to realize it. The worst is not death but being blind, blind to the fact that everything about life is in the nature of the miraculous.

The language of society is conformity; the language of the creative individual is freedom. Life will continue to be a hell as long as the people who make up the world shut their eyes to reality. Switching from one ideology to another is a useless game. Each and every one of us is unique, and must be recognized as such. The least we can say about ourselves is that we are American, or French or whatever the case may be. We are first of all human beings, different one from another, and obliged to live together, to stew in the same pot. The creative spirits are the fecundators: the are the lamed vov who keep the world from falling apart. Ignore them, suppress them, and society becomes a collection of automatons.

What we don't want to face, what we don't want to hear or listen to, whether it be nonsense, treason or sacrilege, are precisely the things we must give heed to. Even the idiot may have a message for us. Maybe I am one of those idiots. But I will have my say.

It's a long, long way to Tipperary, and as Fritz von Unruh has it, "the end is not yet".